SALFORD QUAYS
THROUGH TIME
Paul Hindle

AMBERLEY

Acknowledgements

Most of the old photos were obtained from Salford Local History Library; the librarian Duncan McCormick was, as ever, unfailingly helpful. The new photos were taken by the author.

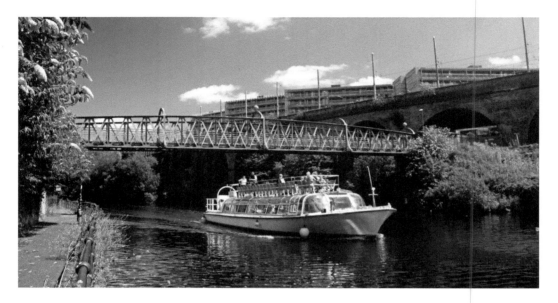

Woden Street Foot Bridge

This bridge, formerly known as Hulme Foot Bridge, links Woden Street off Ordsall Lane to the Hulme area of Manchester across the River Irwell. The name Woden derives from a local cave known as Woden's Den. The area is being massively redeveloped; see the view from the bridge on page 81.

To Maurice

First published 2017

Amberley Publishing
The Hill, Stroud, Gloucestershire, GL5 4EP
www.amberley-books.com

Copyright © Paul Hindle, 2017

The right of Paul Hindle to be identified as the Author of this work has been asserted in accordance with the Copyright, Designs and Patents Act 1988.

ISBN 978 1 4456 7512 1 (print)
ISBN 978 1 4456 7513 8 (ebook)

British Library Cataloguing in Publication Data.
A catalogue record for this book is available from the British Library.

Origination by Amberley Publishing.
Printed in Great Britain.

Salford Quays, Ordsall and Weaste: A Short History in Maps

The development of most of this area is relatively recent, dating back only to the end of the nineteenth century with the creation of 'Salford Docks' at the end of the Manchester Ship Canal, and the associated housing in Ordsall and Weaste. The docks remained in use for less than a century, and the area was redeveloped as Salford Quays and then extended as MediaCityUK.

William Yates surveyed the first detailed map of the area by around 1780, and he shows a few minor roads and houses around New Barn (where Regent Road and Cross Lane now meet). The map also shows Wodens Ford a little way up the River Irwell, which was an ancient crossing place near the confluence with the River Medlock, and there was a cave called Woden's Den, later destroyed. South of the river the Bridgewater Canal can be seen skirting around Trafford Park, linking the Duke's coal mines at Worsley to Manchester. The only other feature shown by Yates was Ordsall Hall, an historic house whose history can be dated back to the thirteenth century, though the oldest surviving parts date from the fifteenth century. It was bought by Salford Council in 1959 and was subsequently opened as a local history museum; it is a Grade I-listed building. It is an amazing survivor in an area that was to be surrounded by nineteenth-century terraced housing.

William Green surveyed a large-scale plan of Manchester and Salford in the years 1787–94. It extends just as far as 'Ordsall Hill', showing the house with its gardens and outbuildings. An interesting feature of Green's map is that it shows who owned each plot of land, including William Egerton, Sir Booth Gore, George Lancaster and the Earl of Derby.

Hennet's map of 1828–29 shows the new Regent Road and Eccles New Road; this was a turnpike created in 1806, complete with a tollbar. It also shows the Liverpool–Manchester Railway alongside (then still under construction). The rest of the area remained largely empty, allowing the cartographer to engrave the word MANCHESTER across this part of Salford!

The first Ordnance Survey 6-inch map of 1848 shows a few changes south of Regent Road/ Eccles New Road, including the Infantry Barracks built in 1819 (where Regent Square was later to be), and a few large houses. Ordsall Hall is clearly shown with its moat, though a chemical works and several Brick Fields have appeared nearby.

Slater's Directory map (1871) shows the first major changes to the area. To the west is Manchester Racecourse, which was moved here from Castle Irwell in 1867. It is one of the strange features that, for most of its history, Manchester Racecourse was in Salford! But crucially the terraced housing has started to appear alongside Eccles New Road and Regent Road, spreading south beyond Tatton Street as well as between the River Irwell and Ordsall Lane. Ordsall Hall itself was still isolated.

The Ordnance Survey 6-inch map (1894) shows more major changes to the area. Most of the area had been covered in a dense network of terraced housing, stretching up to a quarter of a mile south

Yates' map 1780

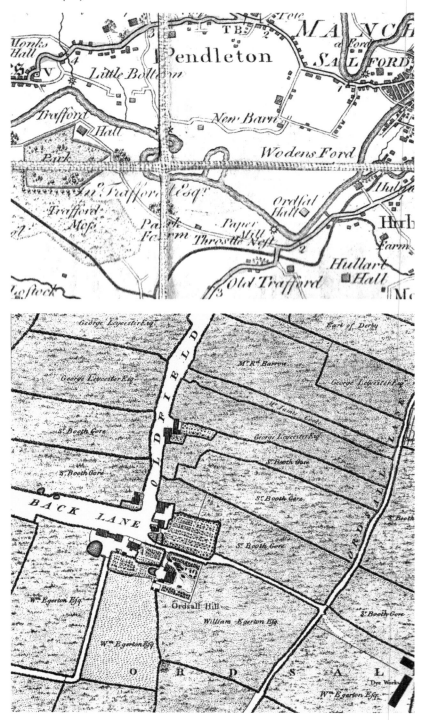

Green's map of 1790

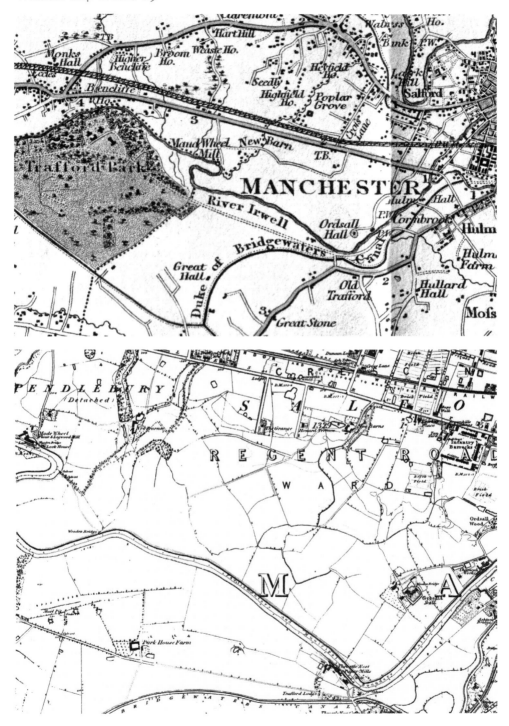

OS 6-inch map of 1848

of Eccles New Road, and almost entirely filling the area between Regent Road, Trafford Road and the River Irwell. Major buildings (churches, schools, barracks and the workhouse) are shown in black. The progress of house building can be seen by the building of churches to serve the new population, starting with the Stowell Memorial Church at the junction of Eccles New Road and Trafford Road in 1869, through to St Ignatius on Oxford Street in 1900. The famous Salford Lads' Club was opened in 1904. Ordsall was, of course, the model for the long-running soap opera *Coronation Street*, which began in 1959. The map clearly shows the Manchester Ship Canal and the new docks, notably Nos 6, 7 and 8. The history of the Ship Canal is a topic in its own right, and has been covered in a previous book in this series. The canal was begun in 1887 and opened in 1894. The main docks were built in Salford as there was plenty of space, whilst only the smaller Pomona Docks (Nos 1–4) were built in Manchester for smaller coastal shipping.

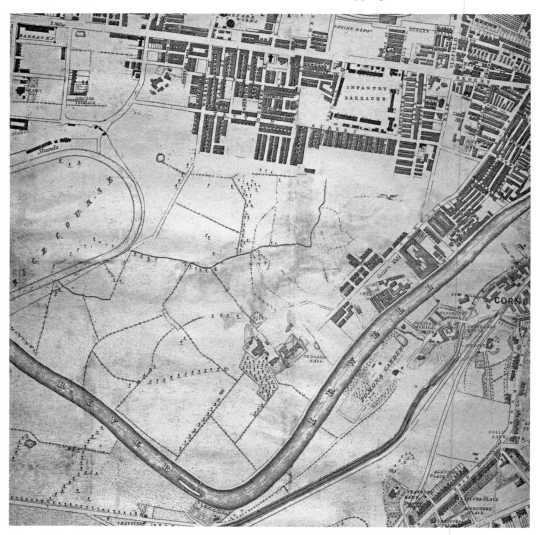

Slater's Directory of 1871

OS 6-inch map of 1894

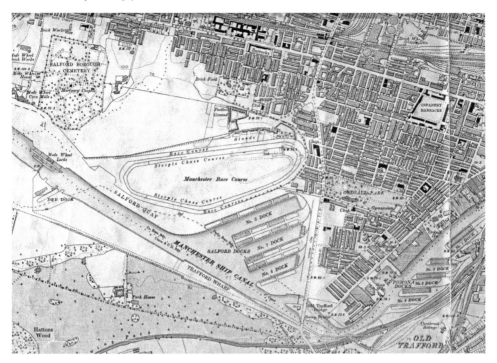

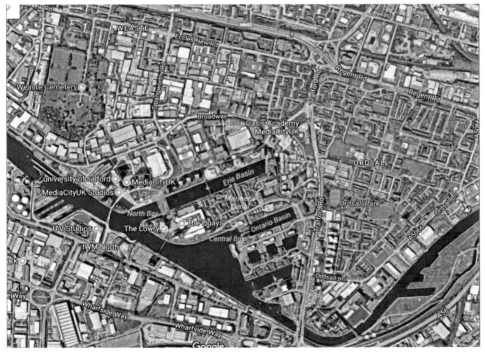

Google Earth, 2017

But the Ship Canal Company needed more docks and storage space, and purchased the area largely occupied by Manchester Racecourse, opening Dock 9 there in 1905. There was soon a large marshalling yard between Docks 8 and 9, and a large grain elevator was opened at the end of Dock 9 in 1915. The docks rose to be the third busiest port in Britain, but the growth of containerisation and the increasing size of vessels meant that the docks went into decline in the 1970s and closed in 1982. Salford Council acquired 220 acres of the site in 1983 with a derelict land grant, and in 1985 rebranded the area as Salford Quays.

The Google Earth image (2017) shows the recent dramatic changes. In the dock area only the outline of the dock basins remain. The docks were maintained as 'water features', with Docks 7, 8 and 9 dammed to keep them separate from the Ship Canal/River Irwell. These three docks were connected by new canals, and the old railway swing bridge was moved to span Dock 9. Most of the dock buildings have been demolished, and a whole set of new buildings has been erected. Most prominent is perhaps the Lowry, a centre for the performing arts, situated on the end of the pier between Docks 8 and 9, with a large outlet mall next door. A lifting Millennium footbridge links the Lowry buildings to the Trafford Wharf, where the Imperial War Museum North is located and a new swing bridge now links back to MediaCityUK. Elsewhere there are business and residential developments, both low and high rise. There are also hotels, restaurants and a watersports centre, all linked by a new road network and a branch of the Metrolink tram system. The latest addition is the creation of MediaCityUK, another mixed-use 200-acre site dominated by the BBC, but also including the University of Salford and ITV.

Meanwhile Ordsall had become one of the most deprived areas of Greater Manchester with high crime rates and gang warfare. Since the late 1950s various urban regeneration schemes have completely redeveloped the area, with the terraced housing replaced by more spacious modern housing, schools and a community centre. Only the area around Regent Square retains any idea of what the whole area was formerly like. No longer is it possible to drive straight through Ordsall. Regent Road and Trafford Road are now wide dual carriageways, with all of the former buildings demolished. On Eccles New Road just three rows of shops survive, and the area to the south is now largely covered in industrial units. Just further north the M602 was built in the 1970s alongside the Liverpool–Manchester railway line. One surprising feature is just how much green space there is in Ordsall, whether as parks or un-redeveloped areas. The one major surviving feature in Weaste is the cemetery (opened in 1857), which is the final resting place of a number of famous local people. One consequence of the major changes in the area is that it is often difficult to match 'then and now' pictures; in the Quays virtually only the outline of the docks remains, whilst in Ordsall and Weaste many of the streets no longer exist.

The area covered by this book is largely that shown on the 25-inch Ordnance Survey map Lancashire 104.09; three editions have been published in the Godfrey Edition as 'Salford Docks' dated 1905, 1916 and 1932. The area to the south is on the 'Old Trafford' sheets (104.13) and to the east is on the 'Manchester (SW)' sheets (104.10). [www.alangodfreymaps.co.uk]

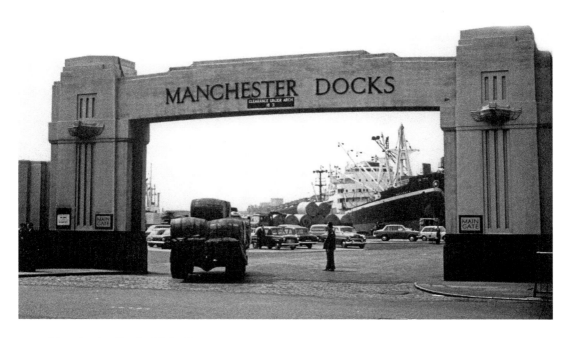

Manchester Docks Main Gate

The main entrance to Manchester Docks was on Trafford Road in Salford. The boat seen above was moored in Dock 8. The arch remains today, and it and the Dock Offices (built in 1926) to the right are virtually the only former dock structures still remaining.

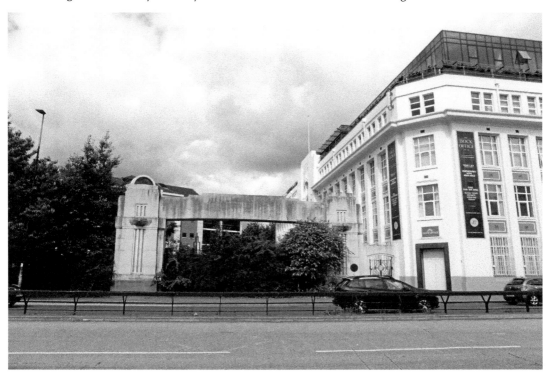

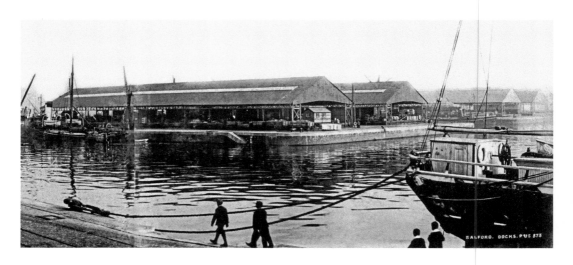

Dock 8

The upper photo was taken in 1894, in the first year of the dock's operation, before Dock 9 had been built. Beyond the two sheds the entrance to Dock 7 can be seen, with more sheds on the pier beyond. The lower photo shows virtually the same view today; only the dock walls and mooring posts survive. Dock 8 has been separated from the river. The sheds have been replaced by offices and low-rise housing, and Dock 7 has been completely closed off.

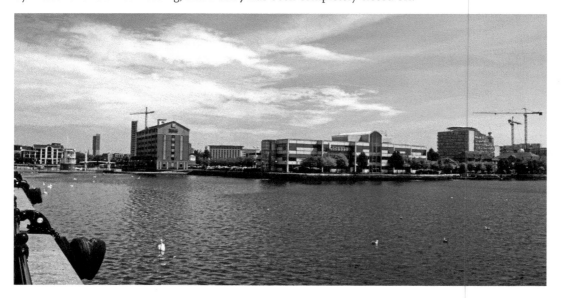

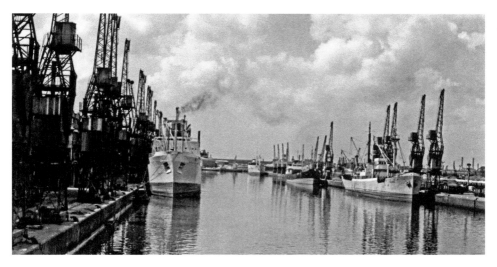

Dock 8

The upper photo, taken in the 1950s, shows the full length of Dock 8 with several ships and many cranes. The lower photo shows a similar view today with the enclosed dock, known as Ontario Basin, opened as Salford Watersports Centre in 2001. There is an office building at the head of the dock, in front of the original Dock Office.

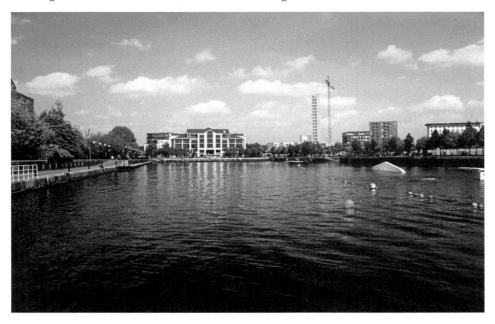

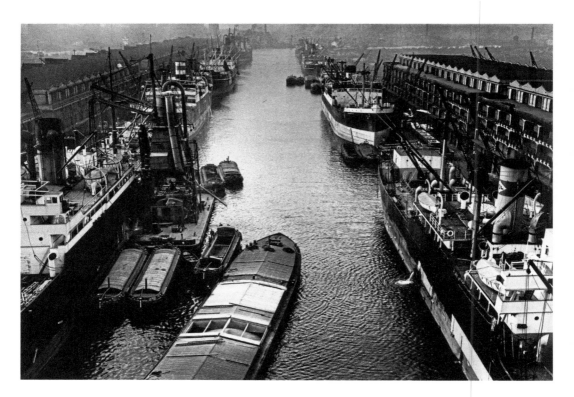

Dock 9

The upper photo, taken in the 1930s from the Grain Elevator, shows a very busy Dock 9 with numerous ships and barges. The warehouses on the right are those shown on page 15, whilst beyond there was a large timber yard. The lower photo shows the same view today, taken from a lower viewpoint. To the left there is the low-rise housing of Anchorage Quay and Grain Wharf, with the Lowry beyond. The basin is spanned by the relocated railway swing bridge (see pages 28–29). The part of the dock in the foreground is now called the Erie Basin, which is continuously aerated. To the right is a row of high-rise buildings.

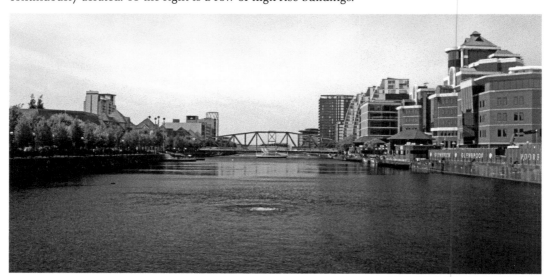

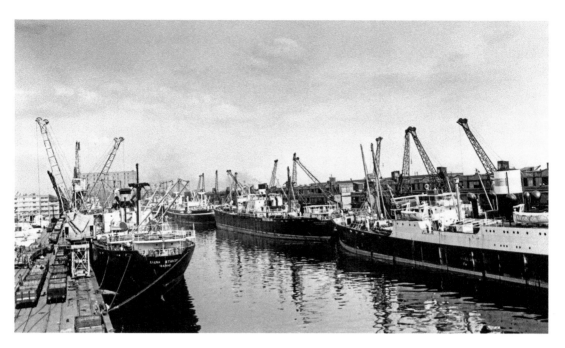

Dock 9

These photos are views of Dock 9 from the entrance. The upper photo, taken in 1953, shows the Grain Elevator at the head of the dock (see page 25). The lower photo shows the Huron Basin, with the impressive sail-like NV buildings on the left. Again the swing bridge spans the dock with the Anchorage building now on the site of the Grain Elevator.

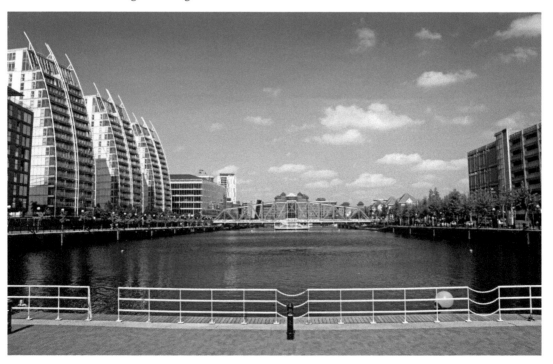

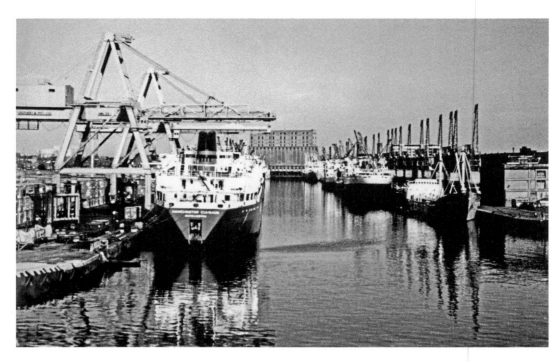

Dock 9

The upper photo shows the container terminal on the left and again the Grain Elevator in the distance. The lower photo closes in on the three eighteen-storey towers of the NV buildings, built in 2004–05, with the City Lofts (2005–07) to the left.

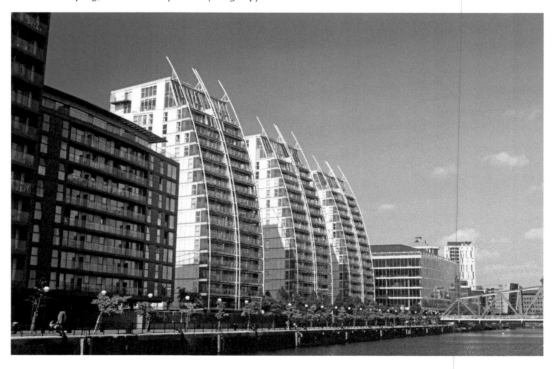

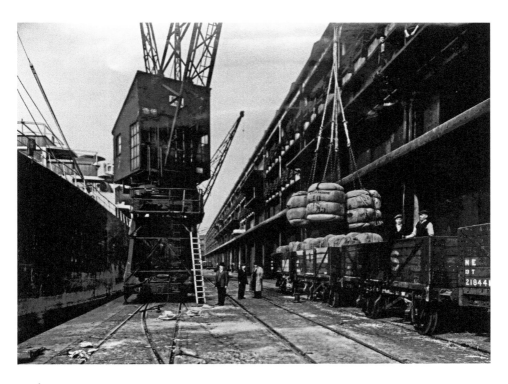

Dock 9
The upper photo, taken in 1948, shows bales of cotton being craned into railway wagons on the side of the dock. There are three railway tracks – one was for the cranes. The lower photo shows essentially the same place, but taken from the opposite side of the dock. Now the warehouses have been replaced by the impressive Victoria Building.

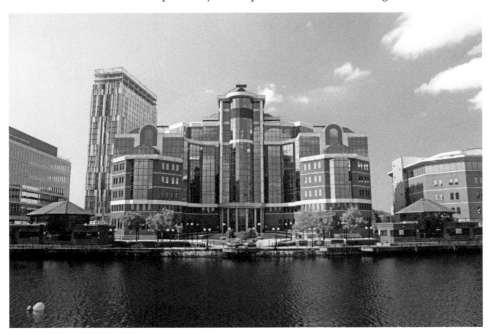

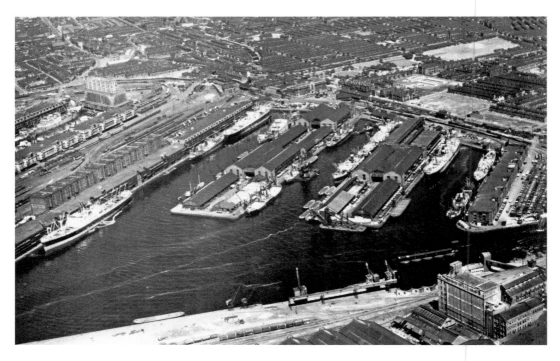

Docks 6, 7 and 8
The aerial photo, taken in the 1950s, shows the three smaller docks with Trafford Wharf in the foreground. The lower photo shows Dock 6 today, still open to the Ship Canal and known as South Bay, with a hotel at the head of the dock and Clippers Quay to the right.

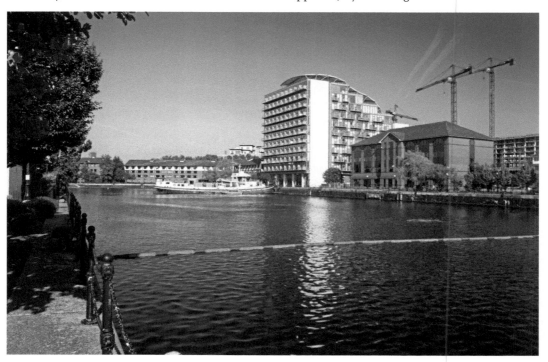

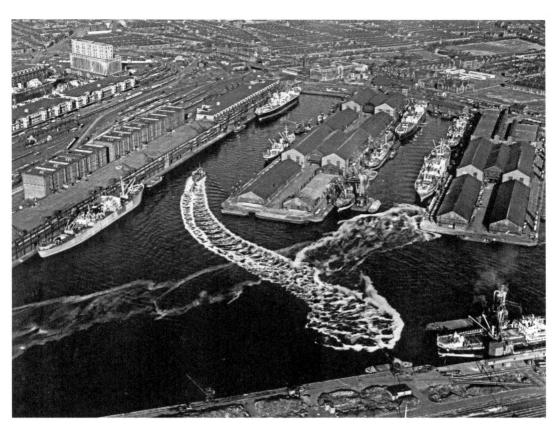

Docks 7 and 8
The lower photo shows the first of three basins of the former Dock 7, now separated from the Ship Canal. This is St Francis Basin, and beyond are St Louis and St Peter Basins.

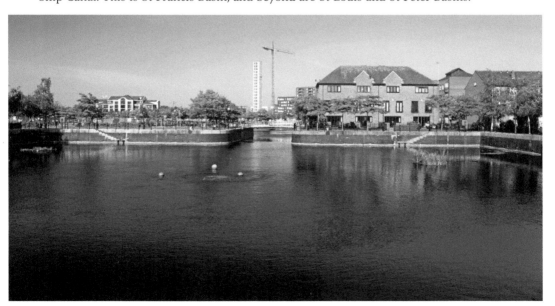

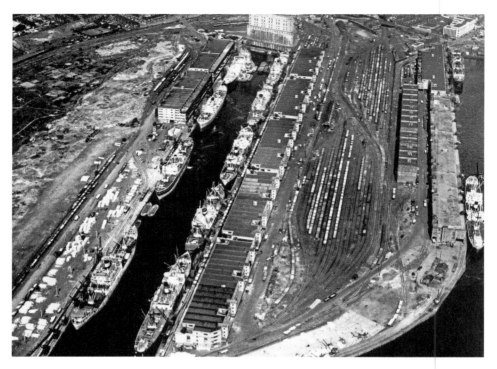

Pier 8

The pier between Docks 8 and 9 is now known as Pier 8. The upper photo shows the massive railway marshalling yard between the two docks. The lower photo, taken from the opposite side of the Ship Canal, shows the Lowry buildings now at the end of the pier with the lifting Millennium Footbridge to the right.

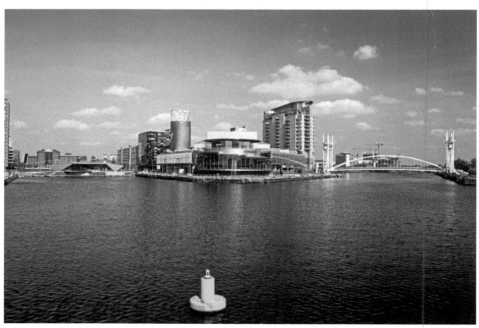

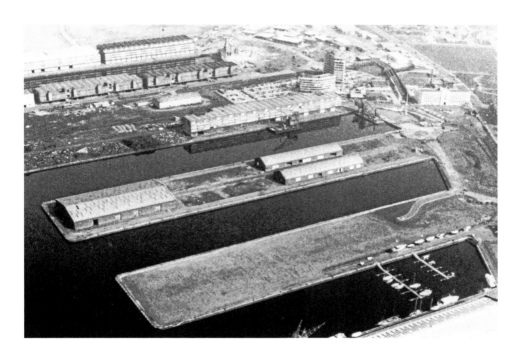

Redevelopment

An unmatched pair of photos illustrating the recent massive changes. The upper photo, taken in 1983, shows the start of clearing the dock buildings around Docks 6, 7 and 8. The Merchants Quay housing was to be built on the empty pier by 1990, and Dock 7 beyond it was to be isolated from the Ship Canal and divided into three basins, allowing maximum waterfront development. The lower photo shows the striking architecture of the Lowry, opened in 2000, with its two theatres, restaurant, bars and, of course, exhibitions of the work of L. S. Lowry.

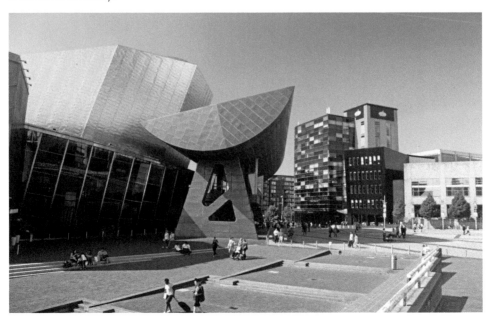

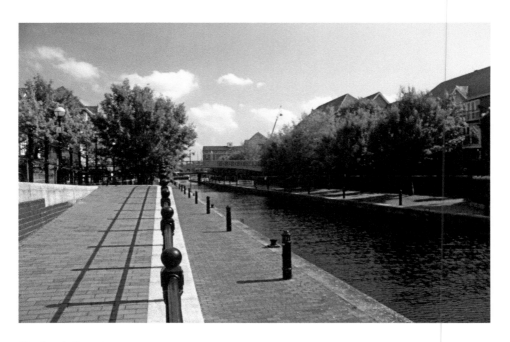

Mariner's Canal

This new canal links Docks 8 and 9. The small stone (below) commemorates the opening of Dock 8 in 1894, and its reopening as the Ontario Basin in 1990, underlining how short-lived the docks were.

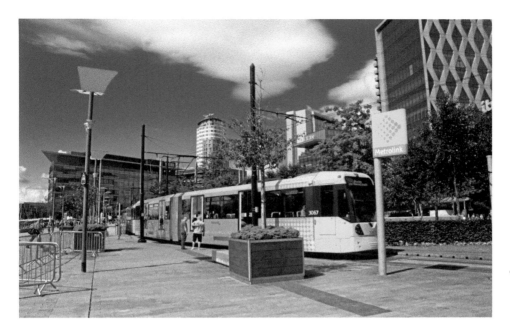

MediaCityUK

This area is effectively an extension of the north side of Dock 9; it was built in 2007–10 and is principally occupied by the BBC, ITV and the University of Salford. There are studios, sound stages and apartments. The upper photo shows a Metrolink tram leaving the MediaCityUK tram stop, which is a short branch off the line to Eccles (see page 34). There are another four tram stops in Salford Quays. The lower photo shows MediaCityUK and the new swing bridge across the Ship Canal.

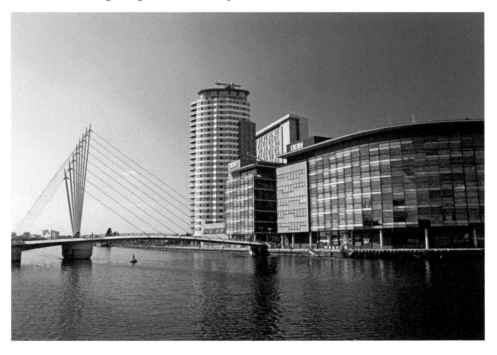

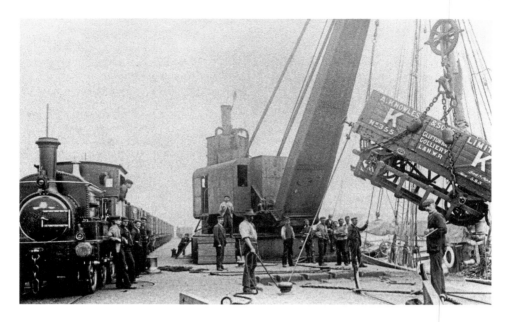

Cranes

The upper photo shows a steam crane lifting a coal wagon from Clifton Hall Colliery. The lower photo shows the two cranes, which were originally installed at Dock 6; they were moved to the Ontario Basin (Dock 8) in 1988 as an iconic reminder of the docks. Controversially they were demolished in 2013 as Salford Council felt it could not afford to refurbish them (at a cost said to be approaching £1 million).

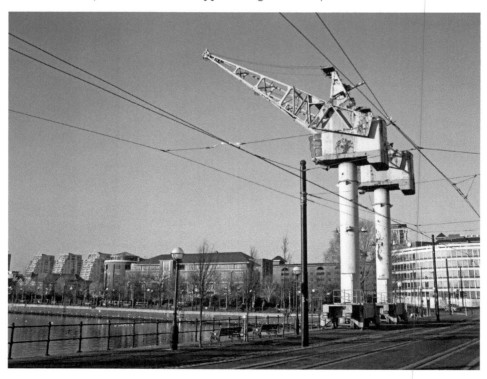

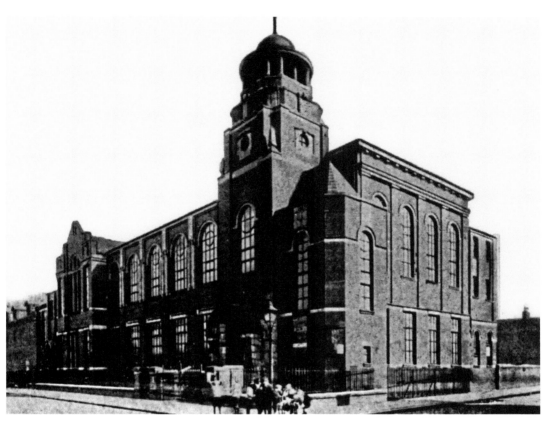

Seamen's Missions

The upper photo shows the Mission Hall on New Park Road, on the south side of Ordsall Park. It was opened in 1915 on the site of a Wesleyan Chapel. The lower, rather posed, photo is the Flying Angel mission on Gladys Street, off Trafford Road, opened in 1901.

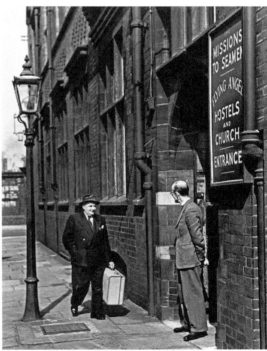

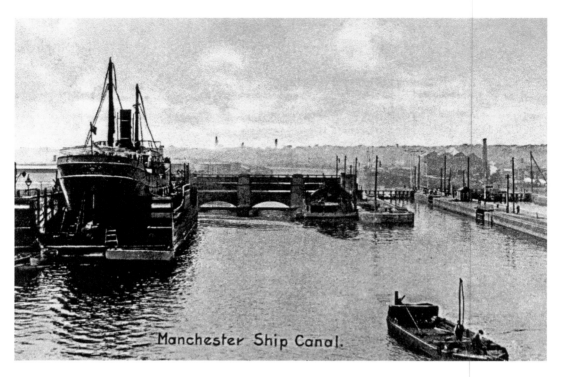

Manchester Ship Canal.

Mode Wheel Locks
The locks are the last of five sets of locks on the Ship Canal, raising ships 13 feet to reach the dock area. The lower photo was taken from the MediaCityUK swing bridge.

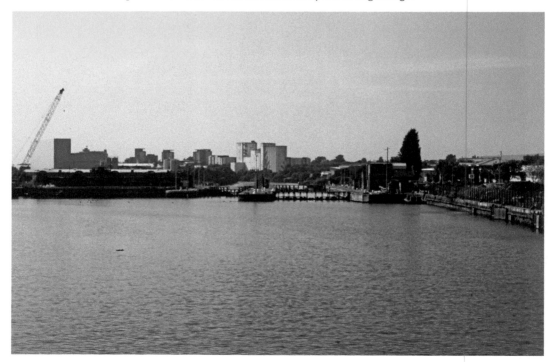

Grain Elevator/The Anchorage

The 168-foot-tall Grain Elevator No. 2 was built at the end of Dock 9 in 1915, and is visible in many of the old photos of the docks. An unsuccessful attempt was made to demolish it in 1983, and it stood at a crazy angle for several months. It has now been replaced by The Anchorage building, opened in 1991.

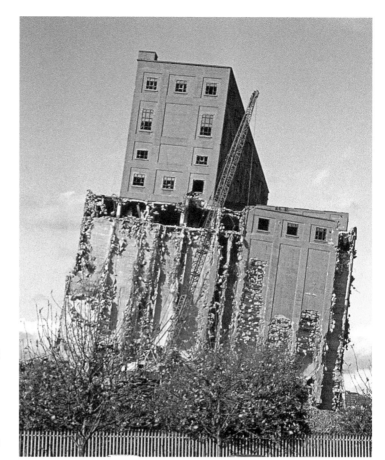

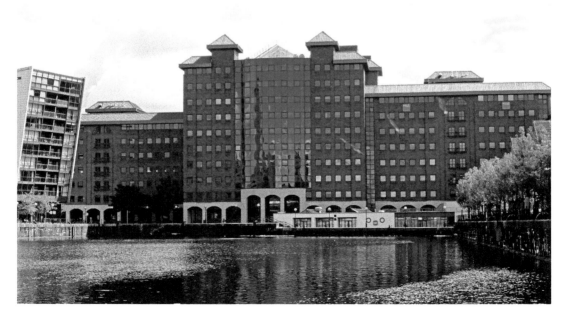

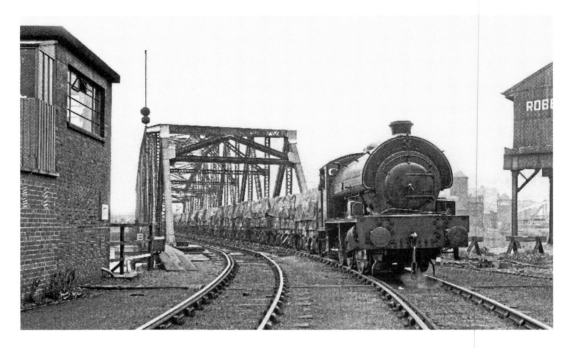

Railway Swing Bridge

The Manchester Ship Canal had its own railway system with around 200 miles of track; there were over seventy locomotives (mostly 0-6-0 tanks to negotiate the sharp curves) and over 2,500 wagons. The system was linked across the canal to the Trafford Wharf by a swing bridge. In the lower photo the Trafford Road swing bridge can also be seen (see pages 30–31).

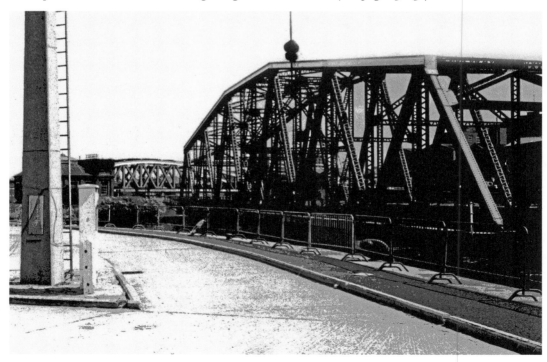

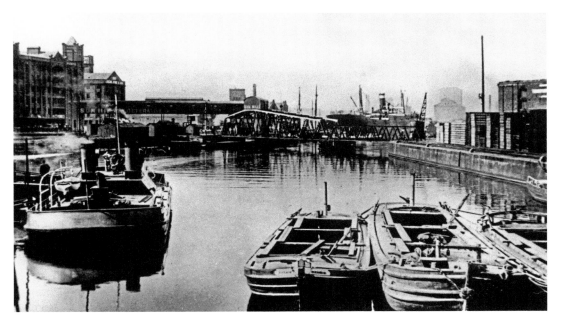

Railway Swing Bridge
The upper photo is looking west with Trafford Wharf on the left, with various warehouses and mills. The lower photo is the reverse view, with Trafford Wharf now on the right, and a burnt-out pub where the swing bridge once rested. Dock 6 is just off to the left.

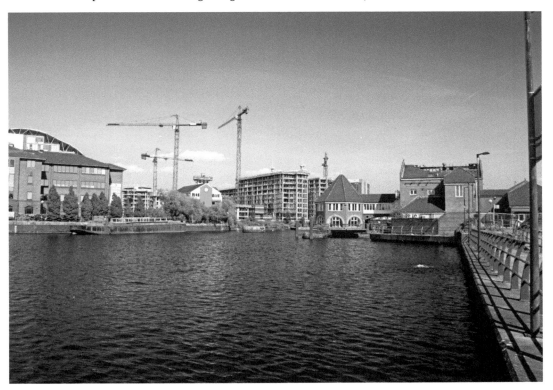

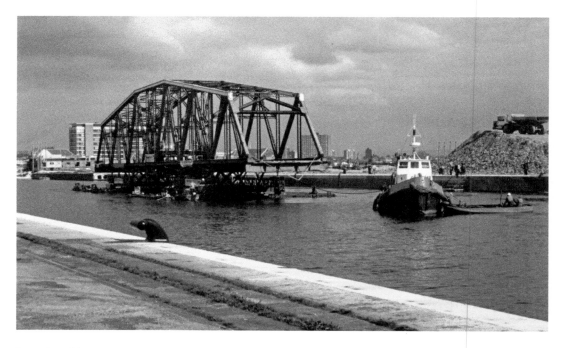

Detroit Bridge

The railway swing bridge was removed in 1988 and towed round to Dock 9 to be installed as a new footbridge spanning the dock. It was renamed the Detroit Bridge, dividing the dock into the Huron and Erie Basins. The lower photo was taken from the south side, with two of the NV buildings visible behind.

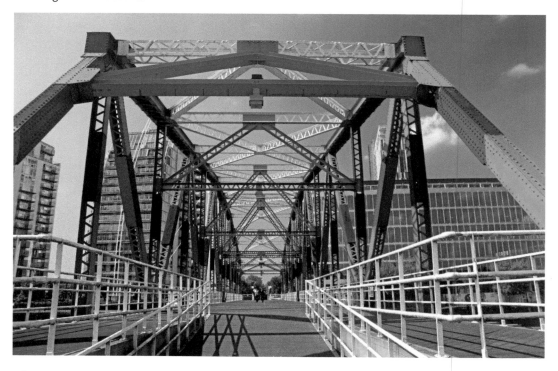

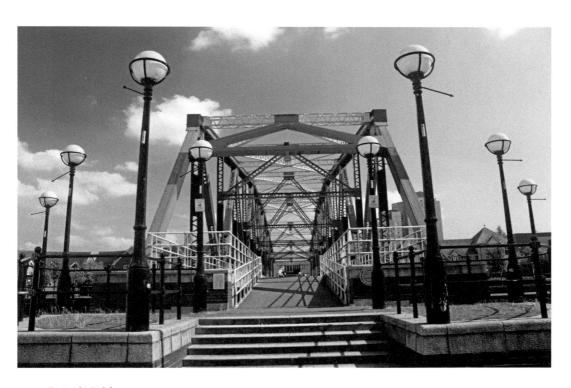

Detroit Bridge
The former swing bridge is now a stunning feature of Salford Quays, seen from the north (above) and from the Huron Basin (below).

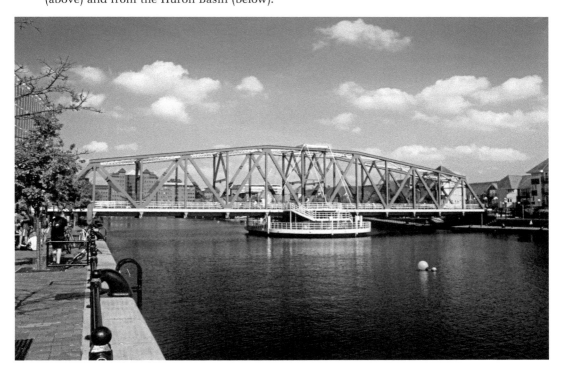

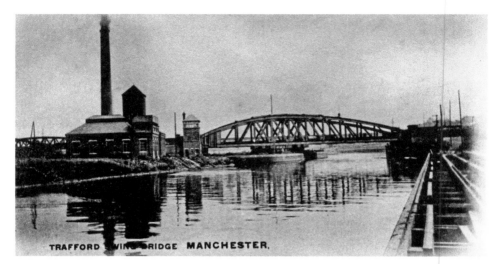

TRAFFORD SWING BRIDGE MANCHESTER.

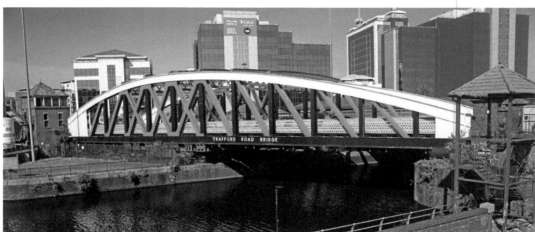

TRAFFORD ROAD BRIDGE

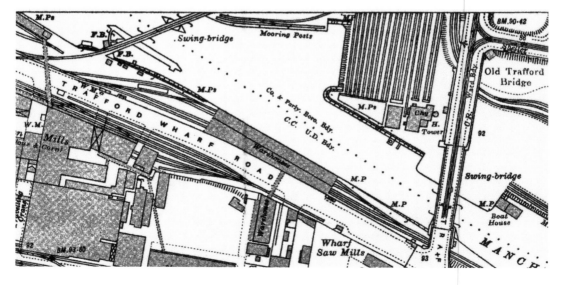

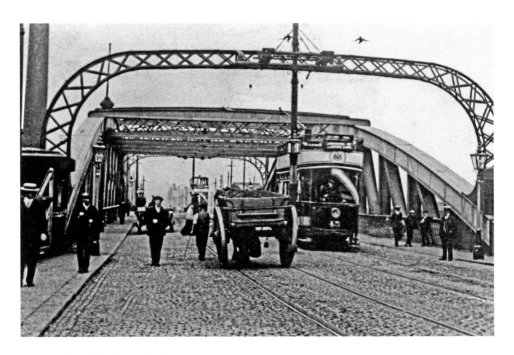

Trafford Road Swing Bridge

Old and new photos of the road swing bridge. In the days of electric trams the overhead wires had to line up accurately to allow trams to pass. The map opposite shows both the road and the railway swing bridges; it also shows Old Trafford Bridge, which was where the road crossed the original line of the River Irwell before the Ship Canal was built. On the photos opposite the hydraulic tower that powered the bridge can be seen.

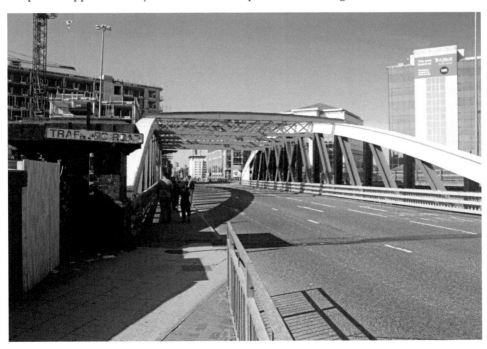

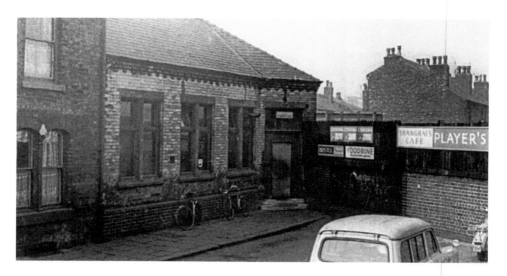

Salford Docks Railway Branch

New Barns Station was opened for racecourse traffic in 1898; the racecourse was closed after only four years, and the station was renamed Docks Station. It was used by dock workers until 1939, but neither the station nor any trains ever appeared in a public timetable. The line was a branch of the Lancashire & Yorkshire Railway, running largely in a series of three tunnels under Ordsall to Windsor Bridge on a steep gradient. The line was closed in 1963, and the lower photo shows one of the tunnels being infilled in 1974.

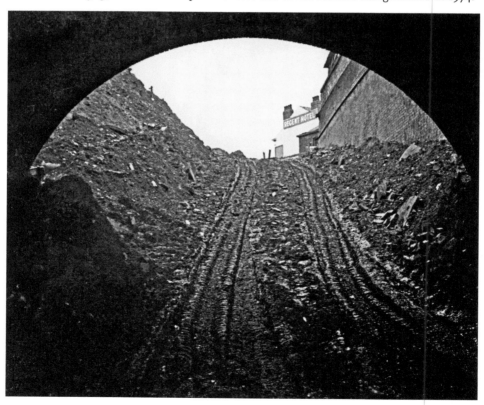

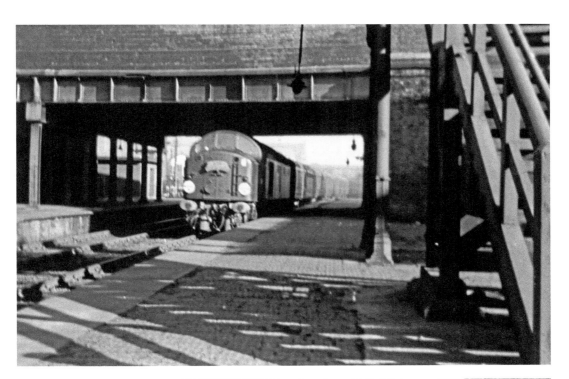

Cross Lane Station

The station was on the Manchester–Liverpool line, immediately west of Cross Lane. It was closed to passengers in 1959 and to goods in 1963. The photo (right) shows the line running in a series of tunnels under the massive roundabout at the end of the M602. The arch is the original Cross Lane Bridge.

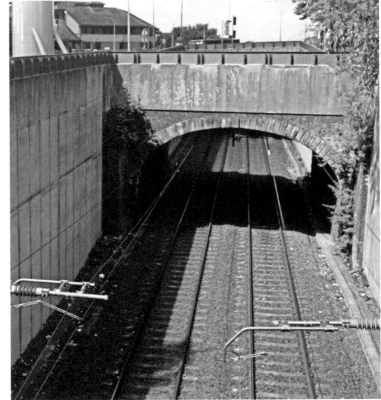

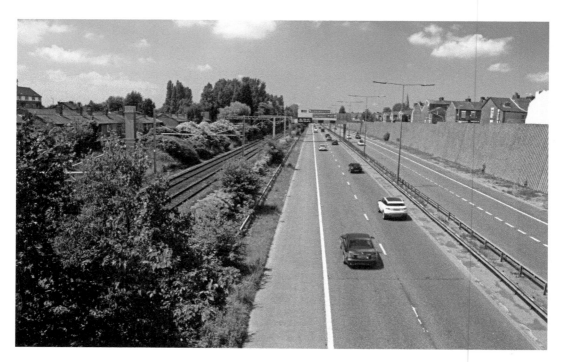

Langworthy Road

Two photos taken from Langworthy Road. The upper photo shows the Manchester–Liverpool railway line with the M602 alongside. The lower photo shows a Metrolink tram at the Langworthy tram stop where the tracks leave Salford Quays to join Eccles New Road.

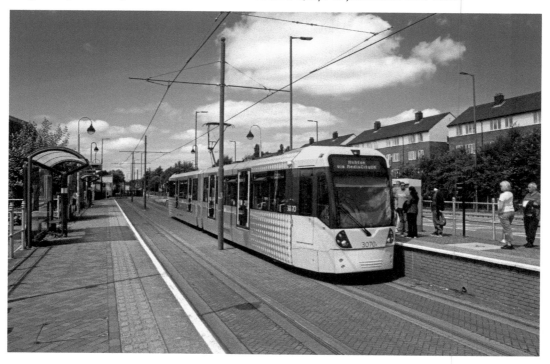

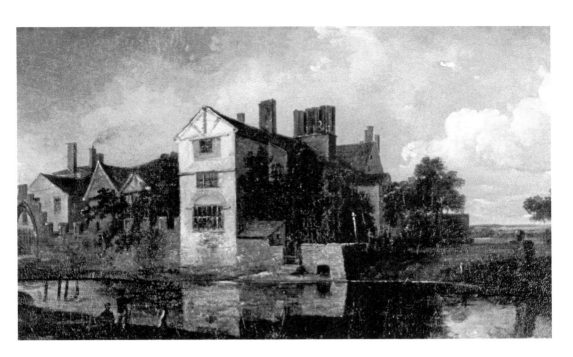

Ordsall Hall

Two early views of the north side of the hall. Above is John Ralston's painting of *c.* 1830, which shows the hall with its moat – it was filled in in around 1850. The photo below was taken in 1875, and shows the poor condition of the building – the exterior had been whitewashed and the quatrefoils covered up.

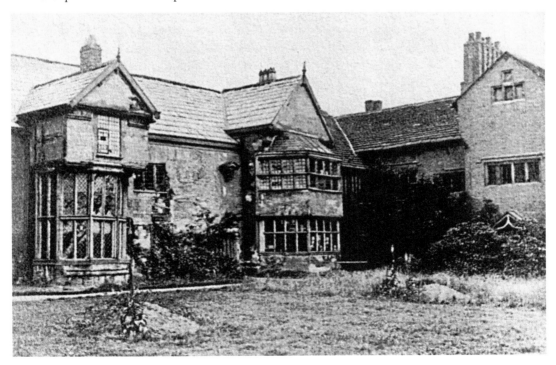

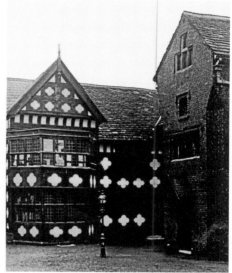

Ordsall Hall

The north side of the hall. The hall was owned by the Radclyffe family from 1335 to 1662, and they built the Star Chamber in around 1360, the timber-framed Great Hall in around 1510, and the brick-built kitchen wing in the late 1630s. The hall had various owners, notably the Egerton family of Tatton from 1758. One tenant was the artist Frederick Shields who lived at the hall in 1872–75. In 1875, the hall was rented to Haworth's Mill for use as a Working Men's Club. When the lease ran out in 1896 the hall was converted into a Church of England clergy training school, and the hall was restored. At the same time St Cyprian's Church was built in the grounds on the left-hand side of the lower photo (see page 40). The clergy left in 1908 and the hall had various uses until it was purchased by Salford Corporation in 1959, despite one councillor describing it as 'a heap of rubbish'. It was opened as a museum in 1972 and was restored again in 2009–11. Entrance is free.

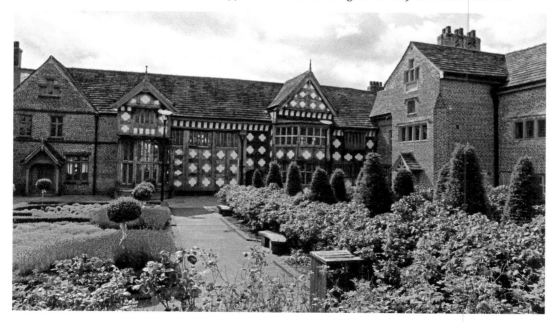

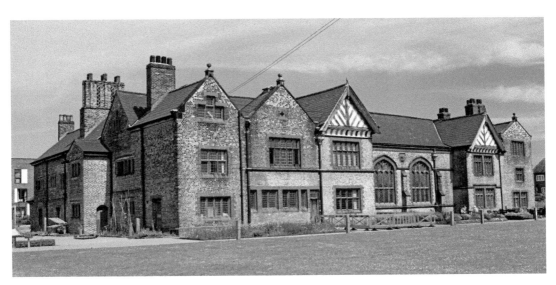

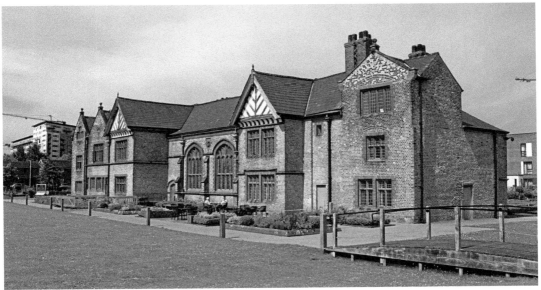

Ordsall Hall

The impressive south front of the hall was originally timber-framed, but was completely rebuilt in brick and terracotta in 1896. By 1900 the hall was totally surrounded by terraced housing and factories. The fact that the hall has survived is simply amazing. In 1841, William Harrison Ainsworth wrote a novel called *Guy Fawkes*. Set in 1605, it tells the fictional story of Guy Fawkes and Robert Catesby planning the Gunpowder Plot at Ordsall Hall, complete with a hidden Catholic priest and an escape through a secret passage. This explains why the road alongside the hall is called Guy Fawkes Street!

GUY FAWKES STREET

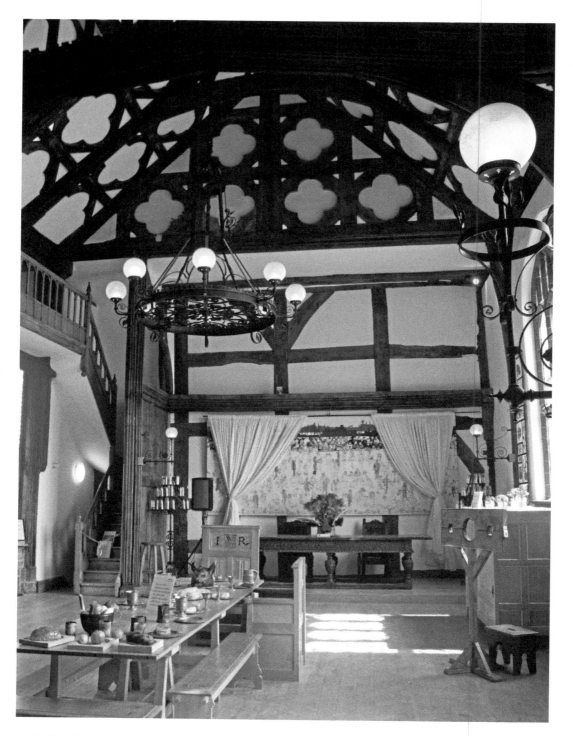

Ordsall Hall
The Great Hall was built by Sir Alexander Radclyffe in around 1510. It is one of the most impressive timber-framed halls in the region.

Haworth's Tatton Mill

The mill formerly faced the hall across Ordsall Lane. The top photo was taken in 1973 just before its demolition. From 1875 to 1896 the hall was a club for the millworkers, who had 'all the privileges of an aristocratic mansion without its expense'. There was a gymnasium, billiard tables, a skittles alley and a bowling green.

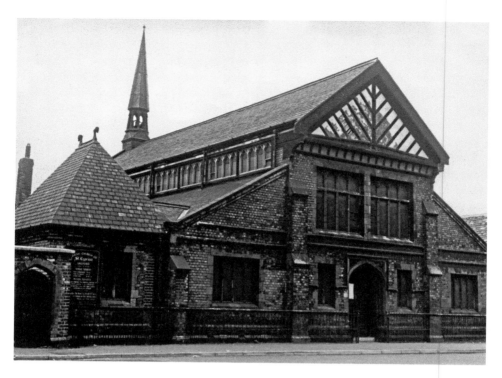

St Cyprian's Church

The church was consecrated in 1899 as part of the clergy training school in Ordsall Hall. It was designed by local architect Alfred Darbyshire, and its half-timbered gable was designed to fit in with the hall. It was demolished in the 1960s due to subsidence.

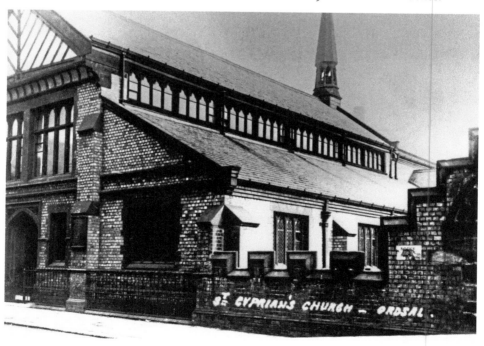

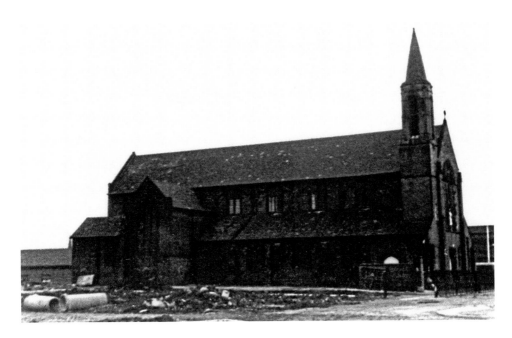

St Joseph's Roman Catholic Church

This church was originally opened in 1871, and the present building dates from 1902. It is in the north-west corner of Ordsall, accessed via Phoebe Street or Goodiers Drive. It has a narrow tower and a short spire. It had a presbytery at the back, and still has a school next door. It was amalgamated with Our Lady of Mount Carmel in 1978 (see page 50).

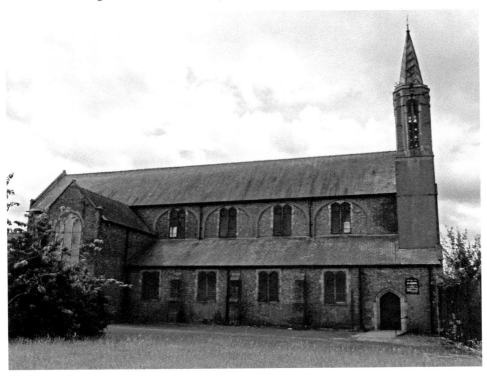

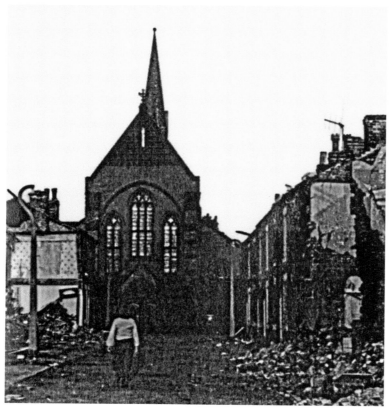

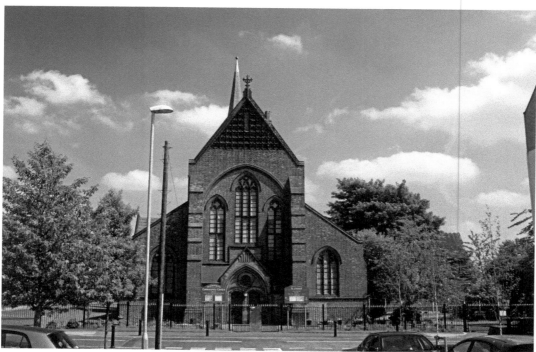

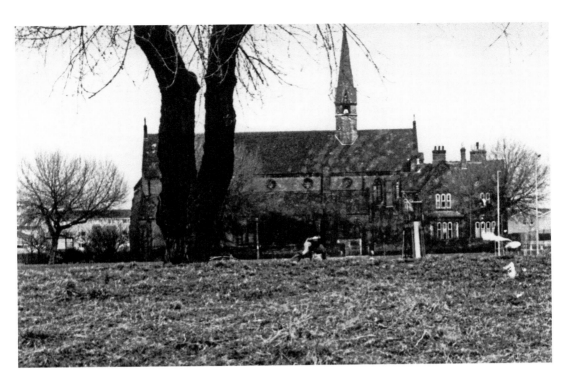

St Clements Church

St Clements was consecrated in 1878, next to Ordsall Park (which opened in 1879). It was designed by the Lancaster architects Austin & Paley, and is Grade II listed. The land was given and the church paid for by Lord Egerton. It is built in brick with terracotta dressings. It is high and spacious, and has a decorative double porch at the west end. The top photo was taken during the demolition of the surrounding houses in the 1970s. The church now also operates as a community centre.

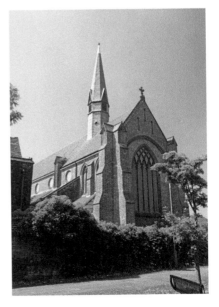

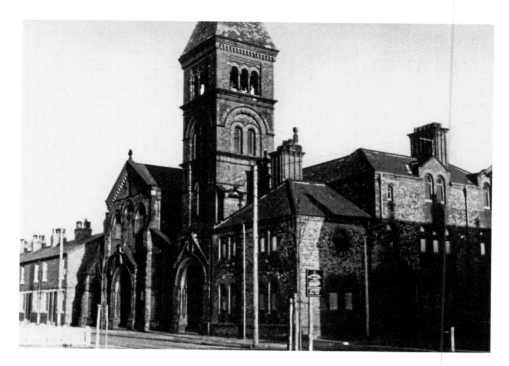

St Ignatius of Antioch Church

This church is another designed by Alfred Darbyshire, best known for his theatre designs. It was built in 1900 on Oxford Street (now St Ignatius Way), as part of the New Barracks Estate in the Regent Square area (see pages 69–70). The church was finally listed as Grade II in 2012, English Heritage describing it as a 'distinctive Romanesque design … with richly detailed friezes, arcading, decorative tympanums, round-headed windows set within elegant surrounds, and elaborate west entrances'. Its campanile tower is equally impressive. However, it had closed in 2004, and was combined with St Clements in the new Ordsall and Salford Quays parish. In 2017, there were plans to use it as a community centre.

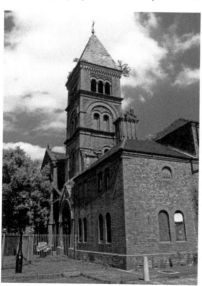

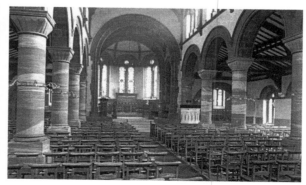

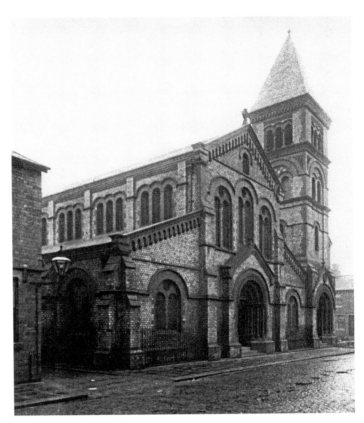

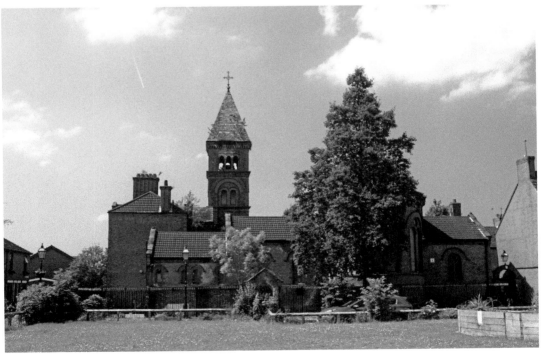

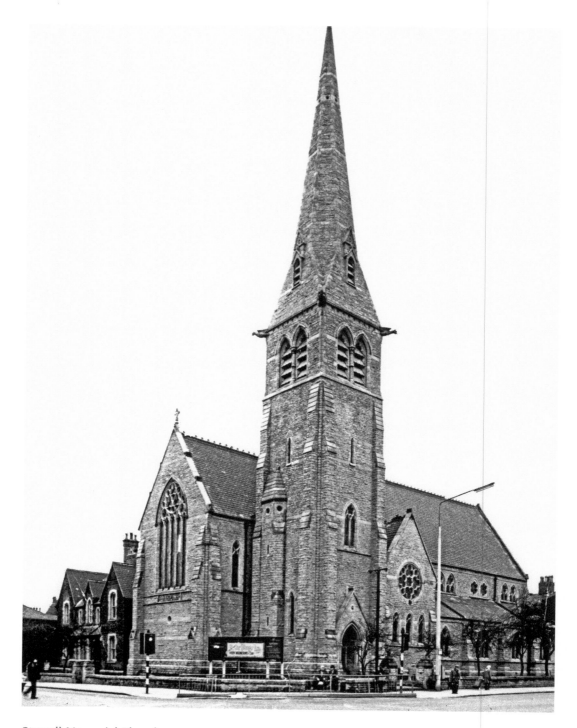

Stowell Memorial Church

This church was a memorial to Canon Hugh Stowell (1799–1865), who was rector of Christ Church where he was a popular preacher. It was the first church to be built in the area, and was consecrated in 1869. The photo was taken in 1974.

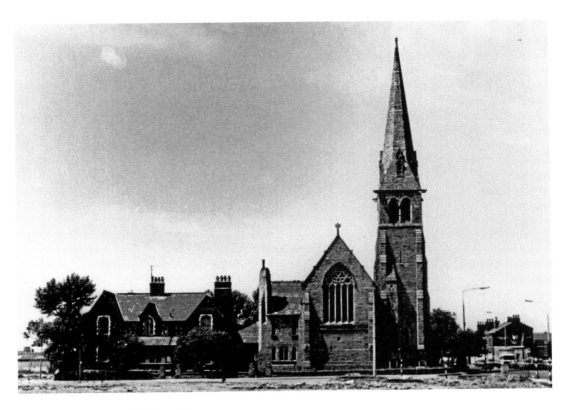

Stowell Memorial Church

The top photo shows the church with its adjacent rectory in 1980, but it closed in 1981. The photo below shows the church burnt out and being demolished in 1983.

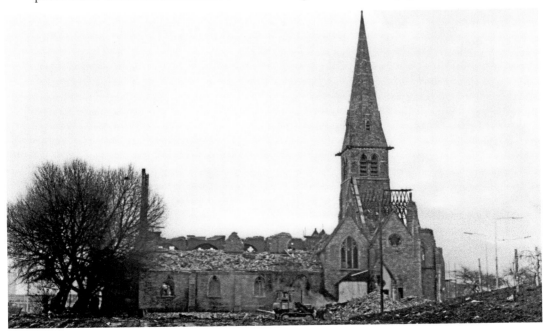

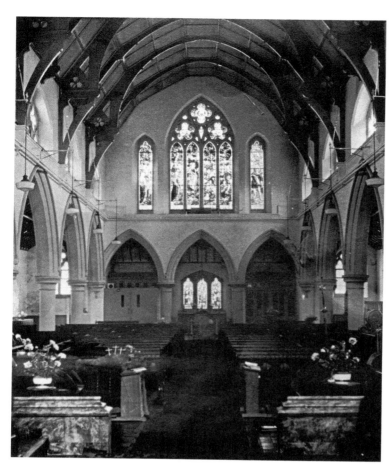

Stowell Memorial Church
Two views of the interior of the church before and during demolition.

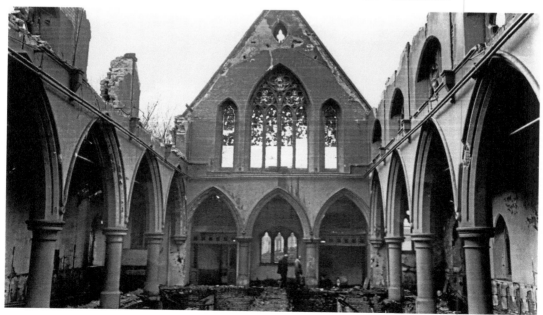

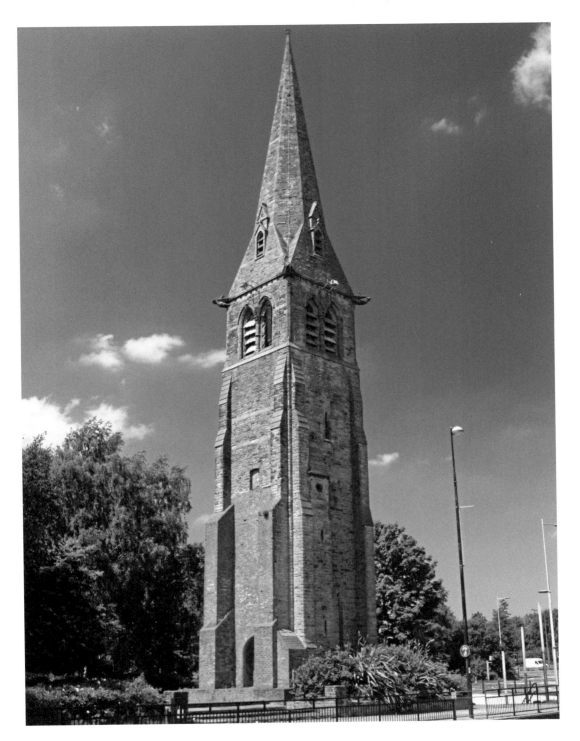

Stowell Memorial Church
The tower and spire were left standing, and it remains a very conspicuous feature in the landscape, as can be seen on pages 56, 57, 59 and 60.

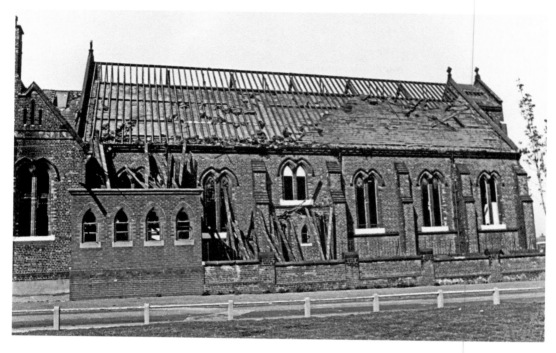

Mount Carmel Roman Catholic Church

Two churches on Oldfield Road have completely disappeared. Mount Carmel Church was demolished in 1978 and combined with St Joseph's (see page 41). The site is now a nursing home, bearing the same name.

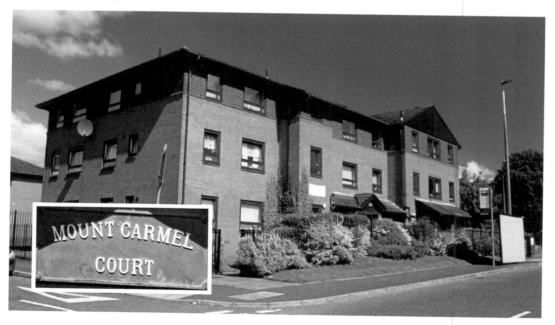

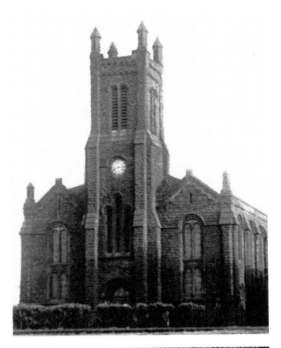

St Bartholomews Church
This church stood further north at the junction of Oldfield Road and Parsonage Street. It survives only as two road names. The church stood on the left-hand side of Parsonage Close.

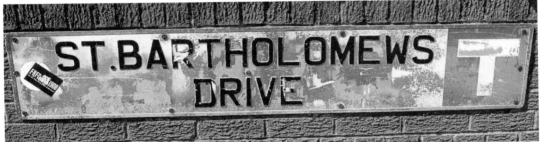

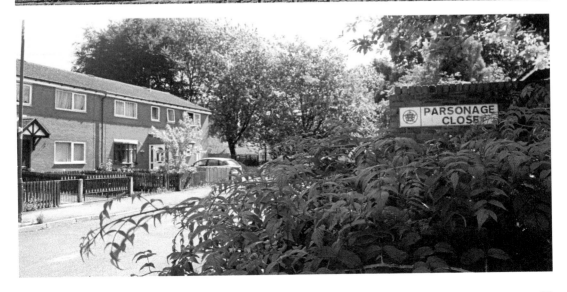

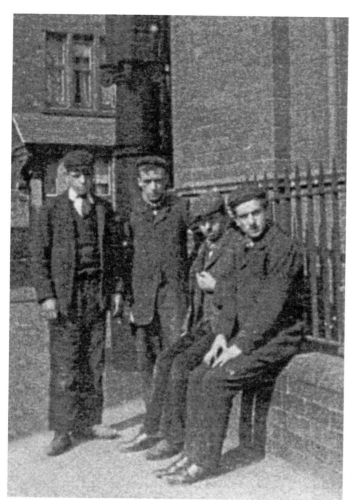

Salford Lads Club
The club was established in 1903 by local brewers James and William Groves. It was opened by Baden-Powell in 1904. It forms part of the New Barracks development (see pages 69–76). It was Grade II listed in 2003, and was described as 'the most complete of this rare form of social provision to survive in England' with its boxing ring, gymnasium and snooker rooms.

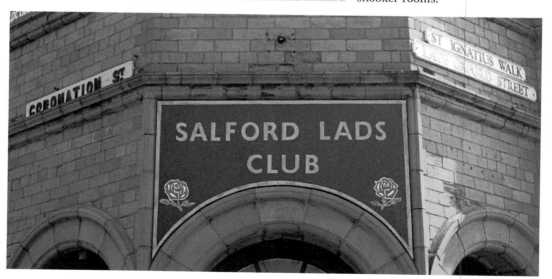

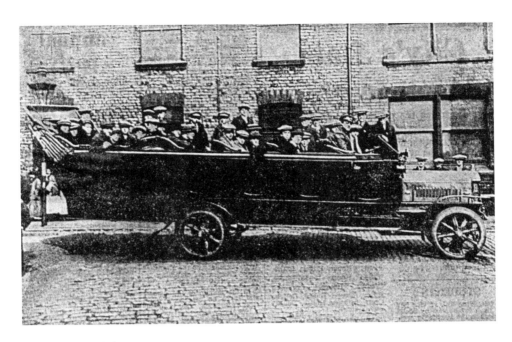

Salford Lads Club

In the photo above lads are seen in a charabanc, setting off for a junior camp in around 1910, probably near Aberystwyth. The building was designed by Henry Lord who was also responsible for the former Salford Royal Hospital and Salford Museum and Art Gallery. The photograph on the inner cover of The Smith's 1986 album 'The Queen is Dead' was taken outside, causing controversy at the time; the club now welcomes fans.

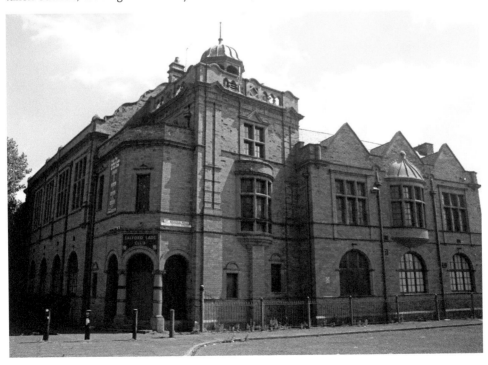

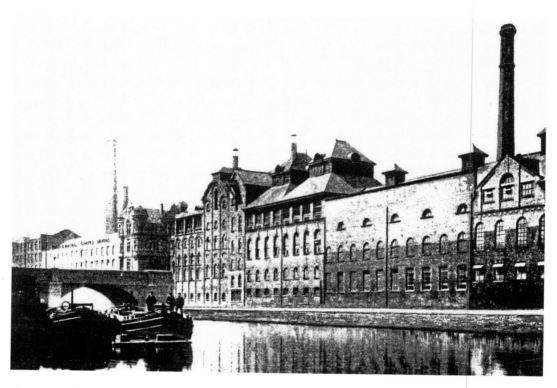

Regent Road Brewery

Groves and Whitnall's Brewery stood next to Regent Bridge. The Campanile Hotel now occupies the site with a new high-rise block of flats in the foreground.

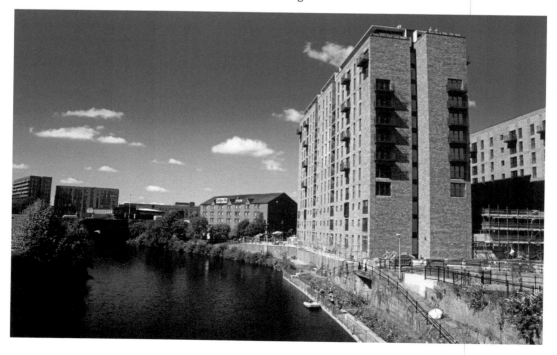

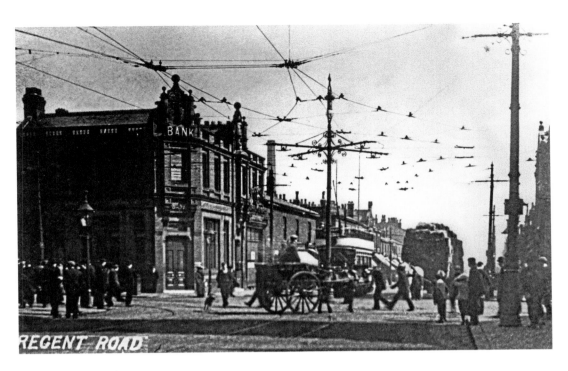

Regent Road

These two photos are not of the same junction, but they demonstrate that all the old buildings along Regent Road have been demolished to make way for the dual carriageway. The upper photo is the junction with Cross Lane looking west, with the mass of tram wires above. The lower photo is the junction with Oldfield Road looking east.

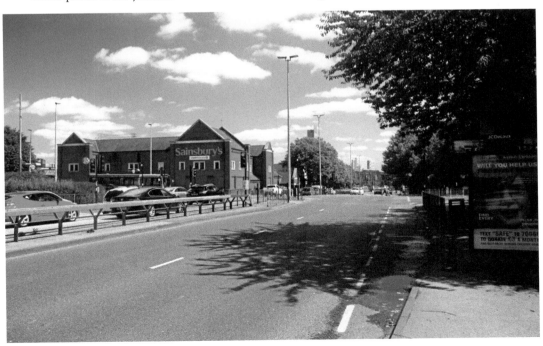

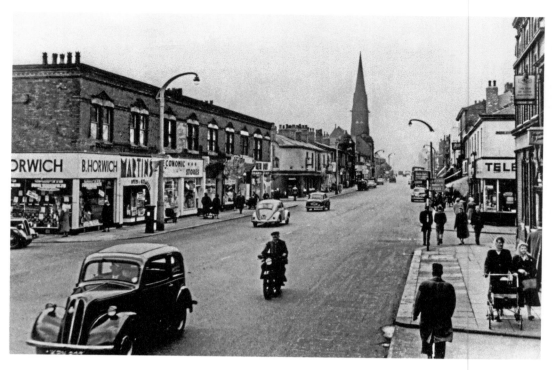

Regent Road

Again all the old buildings have been demolished; only the tower and spire of the Stowell Memorial Church remains.

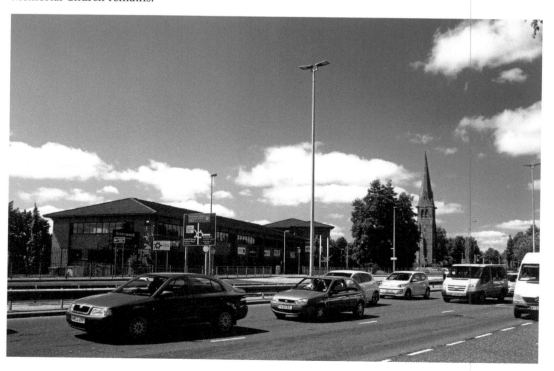

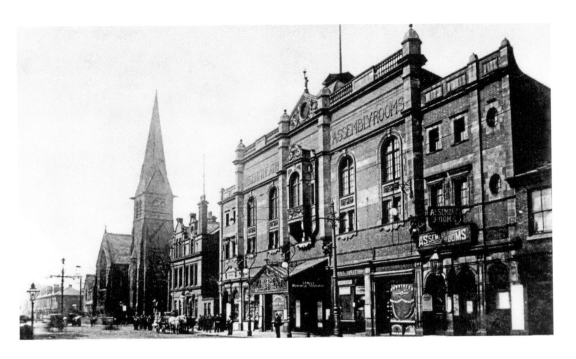

Cross Lane

Once again the Stowell Church is the only common feature. The Regent Theatre was built by Frank Matcham and opened in 1895 with a performance of Wallace's opera *Maritana*. It was later renamed as the Salford Palace, it became a cinema in 1929 and was gutted by fire in 1952. Now the roundabout at the junction of the M602, Cross Lane, Regent Street and Eccles New Road completely fills the site.

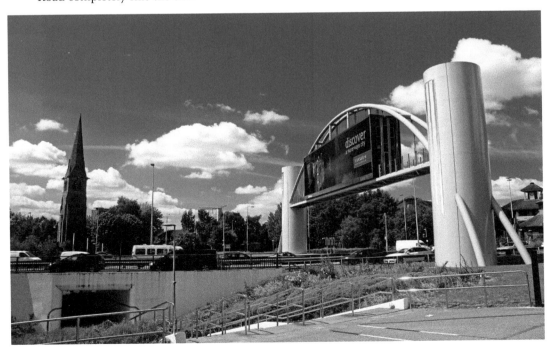

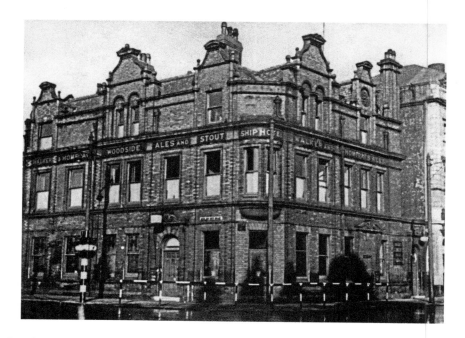

The Ship

Cross Lane once had eighteen pubs in its half mile, but the most well known was probably The Ship at the corner of Eccles New Road. It was an impressive building, known as 'the theatricals house of call' (the Regent Theatre was next door), but equally known by sailors. The upper photo taken in 1948 shows it belonging to Walker & Homfrays' Woodside Brewery, just a block away. It was taken over in 1949 by Wilson's Brewery in Newton Heath, as seen in the lower photo. It closed in 1973 and like most buildings here it was demolished to make way for the M602 roundabout.

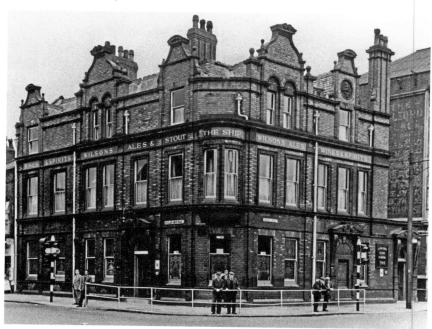

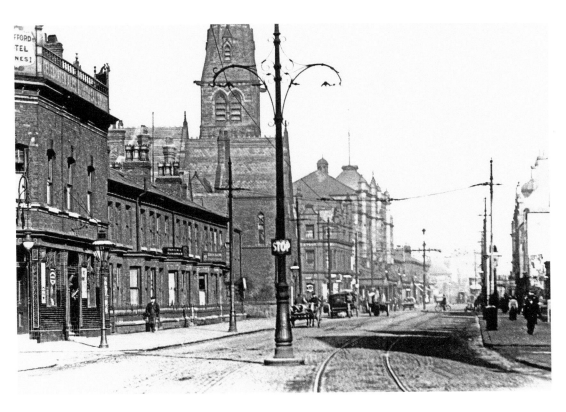

Trafford Road

Two views looking north up Trafford Road with the Stowell Church once again prominent. In the upper photo, taken in the first decade of the twentieth century, the Trafford Hotel is just in view, whilst part of the Clowes Hotel can be seen on the left in the lower photo.

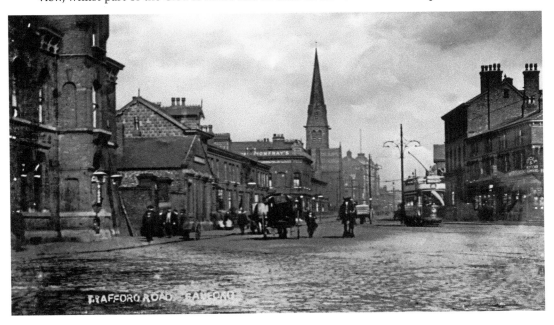

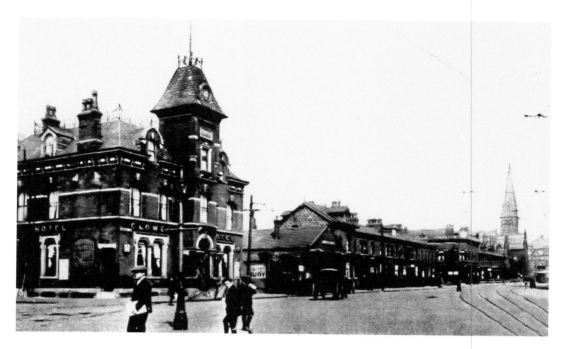

Trafford Road

Now at the junction with Broadway, the Clowes Hotel is clearly visible in the upper photo, taken in 1923. The lower photo shows that all the former buildings have gone to make way for the wide dual carriageways.

Salford Central Mission

These photos are the reverse view of those on page 60. The imposing mission building was a Congregational (later United Reformed) church, opened in 1907 at the junction of Trafford Road and Broadway. It was demolished in 2011 to make way for the Oasis Academy MediaCityUK School.

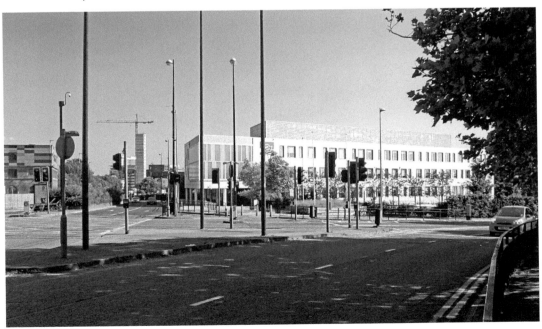

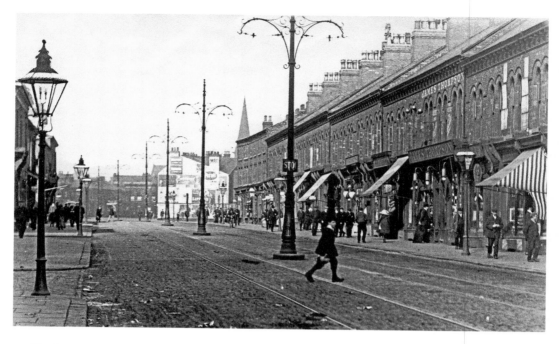

Trafford Road

The upper photo, taken in the first decade of the twentieth century, shows a row of shops just north of Ordsall Park – the Stowell Church spire is once again visible. One shop is clearly identifiable as Jas. Thompson, pawnbroker. To the right was an undertaker and a wine and spirit merchant, whilst shops to the left included a hatter, an eating house, a steam laundry, and dealers in fried fish, tripe and oysters. The lower photo was taken just south of Ordsall Park, showing that all of the old buildings have long gone.

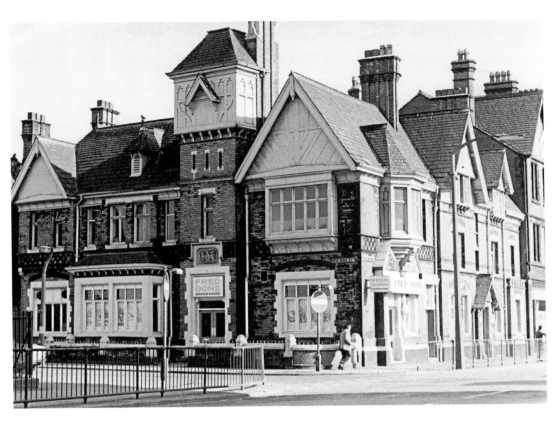

Old Police Station

The photo of the old police station at the junction of Trafford Road and New Park Road was taken in 1977 when it was being used as a betting shop. A supermarket now stands on the site.

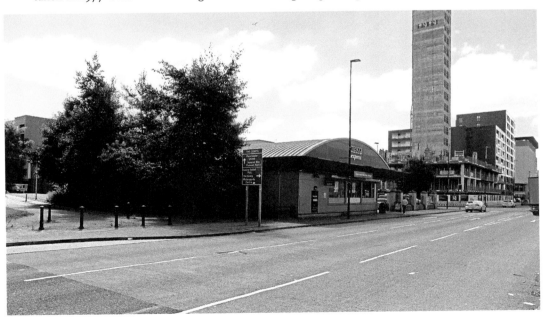

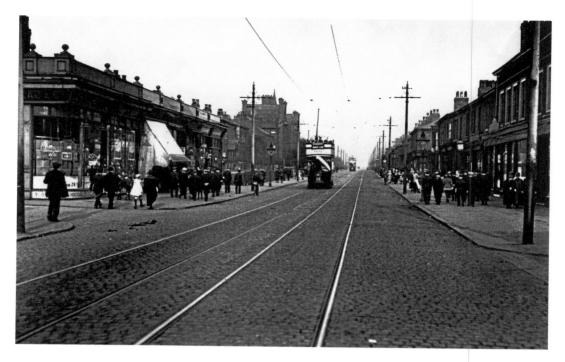

Eccles New Road

Three rows of shops survive on the south side of Eccles New Road, which has not been widened. The upper photo, taken in the 1920s, may show the workhouse just left of centre. The lower photo shows the former Waverley Hotel at the junction with Thurlow Street, just opposite the site of the workhouse.

Eccles New Road
The road has remained relatively quiet since the upper photo was taken in 1978.

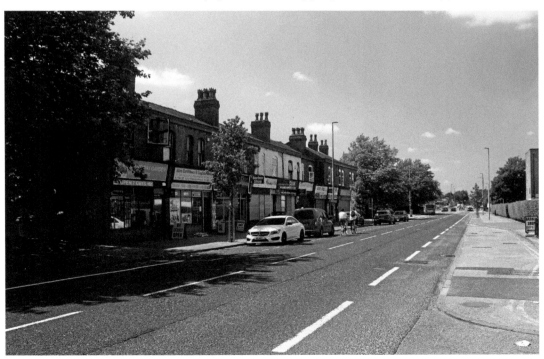

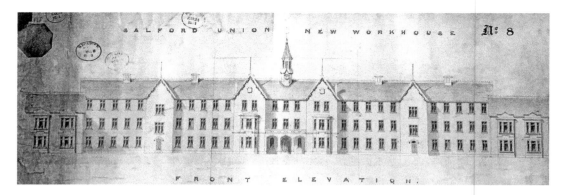

FRONT ELEVATION.

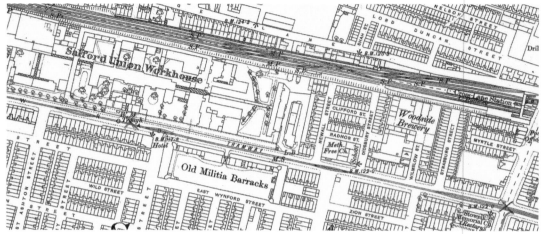

Salford Workhouse

The workhouse was built in 1852, designed by Pennington and Jarvis to house 300 inmates. The 1896 map also shows the old militia barracks, Woodside Brewery and Cross Lane Station. The workhouse was closed soon after the First World War and demolished in 1930. The narrow site between the road and the motorway is now filled with apartments.

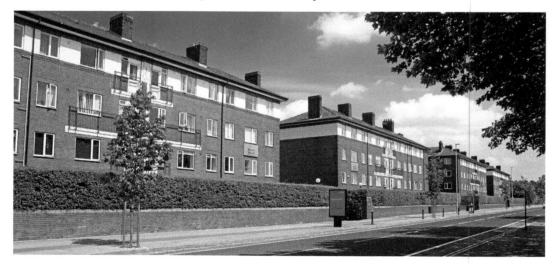

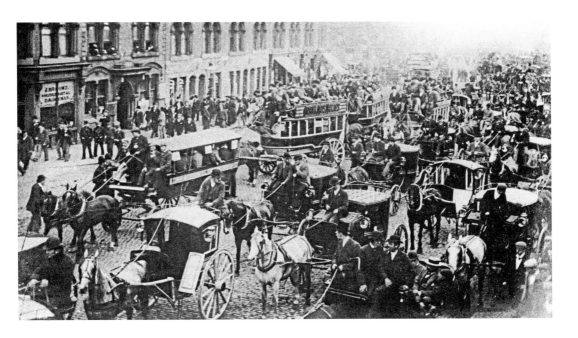

New Barns Racecourse

Manchester Racecourse was moved here from Castle Irwell in 1867. The photo shows the heavy race traffic on Trafford Road in the 1890s. The 1896 map shows the 100-acre racecourse in great detail with the two courses, a trotting course, several stands and a grandstand, a paddock, two judge's boxes, a winning post and four urinals! By 1896 the Ship Canal Docks 6–8 had been constructed, and the racecourse saw its last race in 1901, after which the course was moved back to Castle Irwell, and Dock 9 was built on the racecourse site. A proposed Dock 10 was never built.

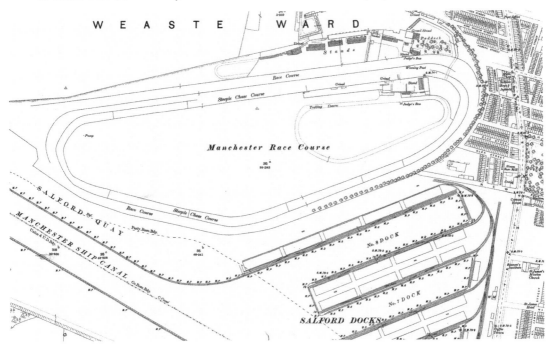

New Barns Racecourse

Two views of Manchester Racecourse in its heyday. For most of its existence, Manchester Racecourse was in Salford – first on Kersal Moor, then at Castle Irwell, then at New Barns, then back to Castle Irwell where it remained until 1963. Its final site became a student village for Salford University.

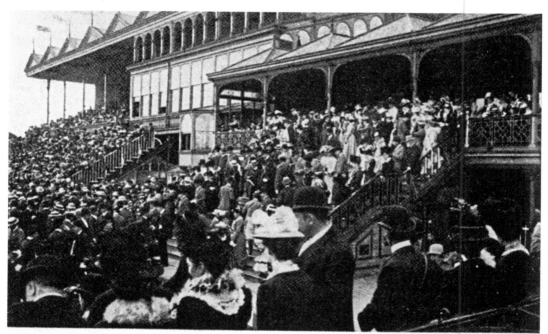

A VIEW OF THE FASHIONABLE CROWD IN THE COUNTY CLUB ENCLOSURE

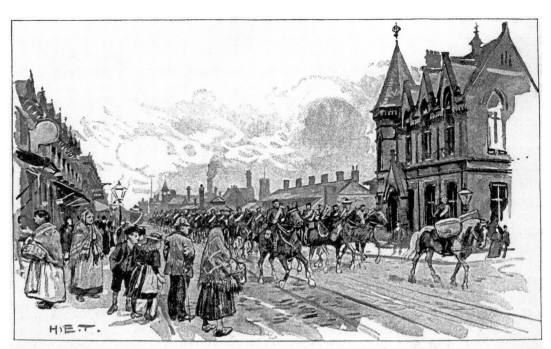

SALFORD FOOT BARRACKS, REGENT ROAD, AND FREE LIBRARY.

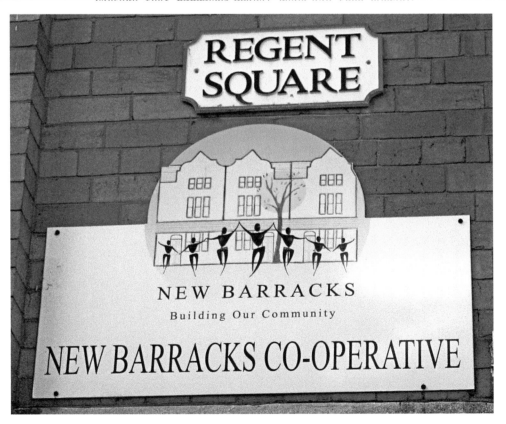

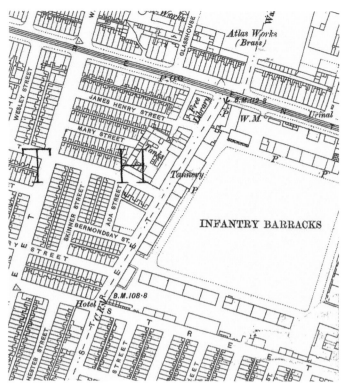

Salford Barracks

The Infantry Barracks on Regent Road were begun in 1819, soon after the Peterloo Massacre; the print opposite shows them next to the Free Library at the junction with Oxford Street. The barracks were vacated in 1896, but the Ordnance Survey map of that year (above left) shows the barracks still intact. Salford Corporation bought the site for £38,500 and it became Salford's first redevelopment scheme. By 1905 the lower map shows the area completely altered, with the construction of half a dozen new streets, a recreation ground, the Lads Club, a Girls' Institute and St Ignatius Church. This development today remains remarkably intact; the memory of the barracks is still preserved in the name of the co-operative.

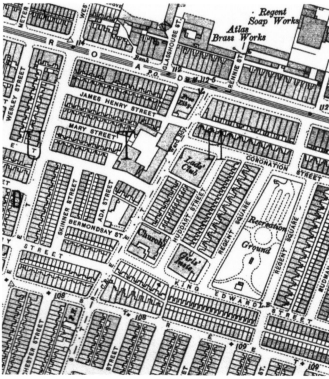

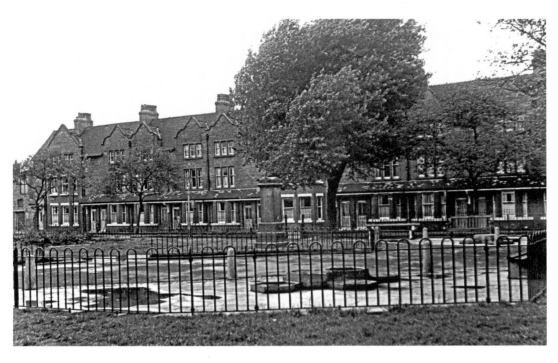

Regent Square
The small park is at the centre of the former barracks area; it still has its memorial. The upper photo was taken in 1972.

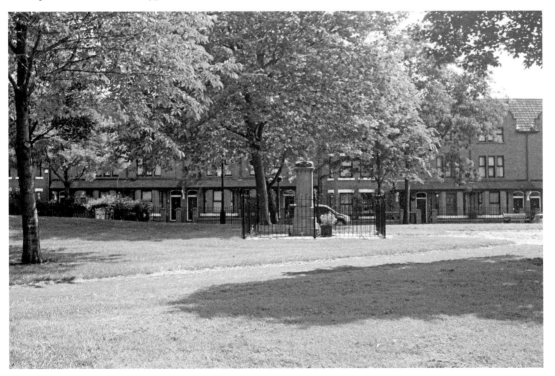

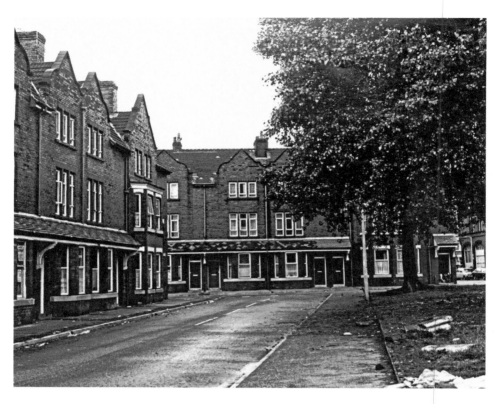

Regent Square
This is the west side of Regent Square leading into Coronation Street, which runs across the north side of the area. The upper photo was taken in 1978.

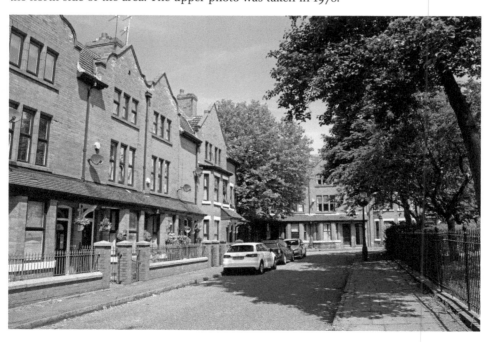

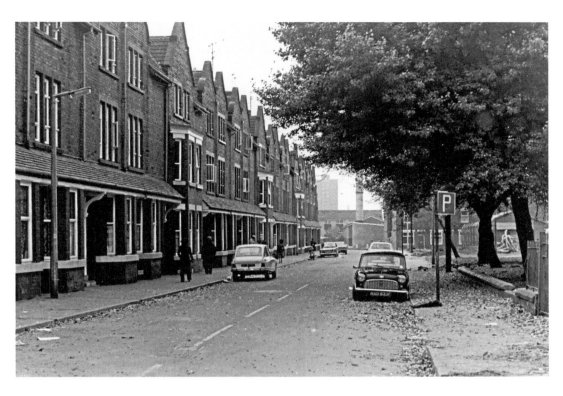

Regent Square
The east side of Regent Square, with the park on the right. The upper photo was taken in 1978.

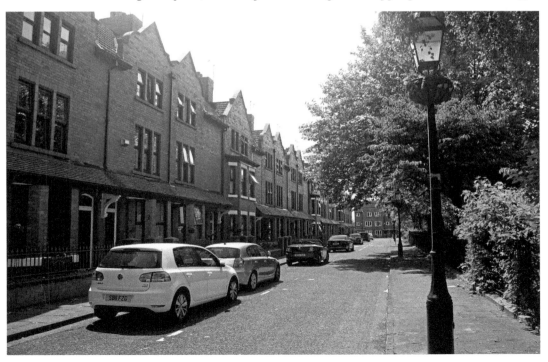

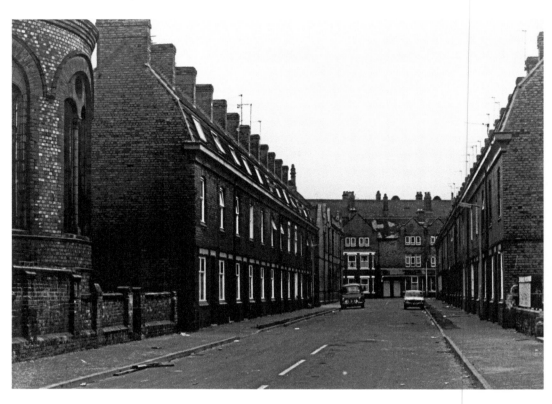

Huddart Street

This is one street west of Regent Square, at the junction with King Edward Street. The upper photo was taken in 1978.

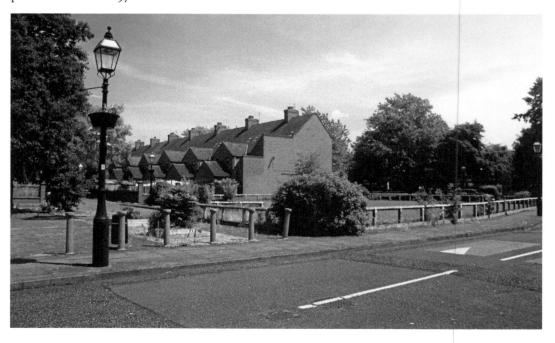

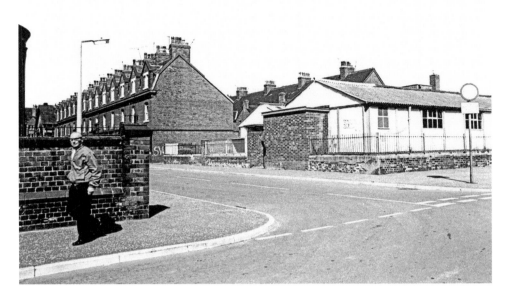

Huddart Street

This street is now much opened up as the houses on the right-hand side (seen above in 1978) have been demolished to make way for a more open and greener environment. The back of St Ignatius Church can be seen on the left of the bottom photo. The prefabricated building to the right was a children's dining centre built on the site of the Working Girls' Club, which was destroyed during the Second World War.

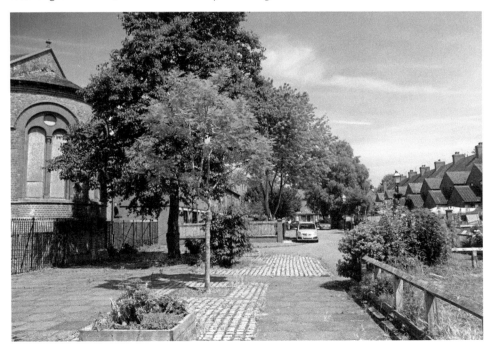

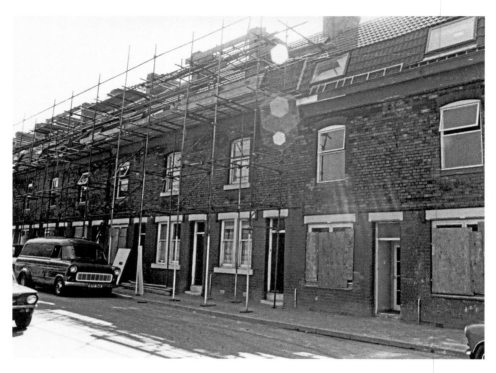

King Edward Street

This street was created along the southern boundary of the barracks site. The upper photo was taken during refurbishment in 1987.

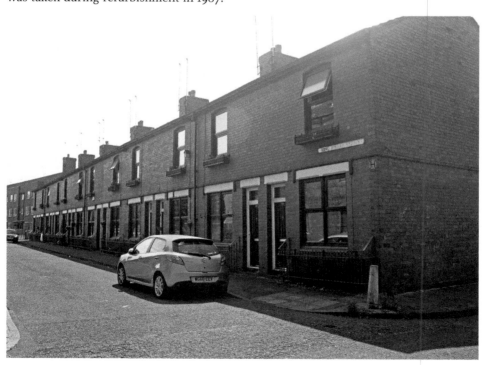

Phoebe Street

In 1959 two Wolf Cubs stand in the middle of Phoebe Street, which once ran all the way north to south through Ordsall from Ordsall Park to Regent Road. Today, at the junction with Robert Hall Street, the view is rather different, and, behind the camera, Phoebe Street now turns westwards onto what was formerly West Park Street.

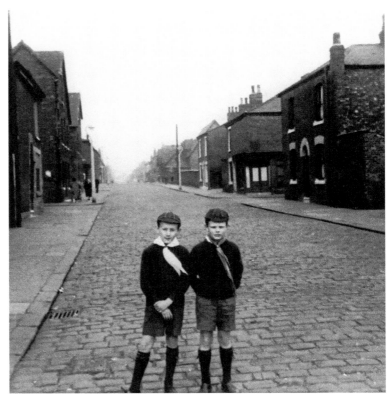

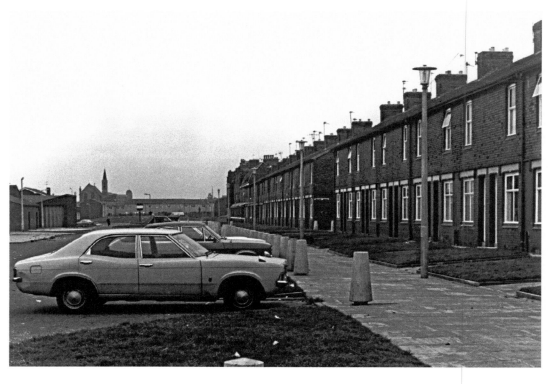

Tatton Street

This street also once ran all the way through Ordsall, west to east from Broadway to Oldfield Road; just a short length now remains. The upper photo was taken in 1978.

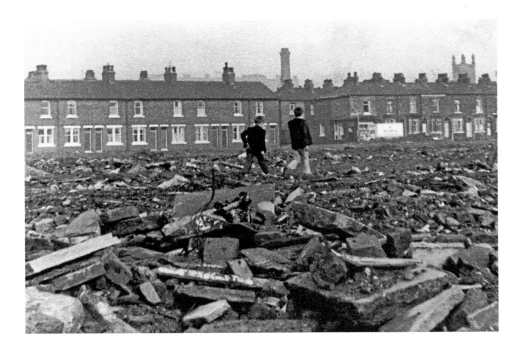

Tatton Street

The upper photo, taken in 1973, shows the sheer scale of the redevelopment; the church in the background is probably St Bartholomews (see page 51). The lower photo shows a row of surviving housing. The end building, which was once at the junction with Oxford Street, now houses the Ordsall Community Café. It is just a block south of King Edward Street (see page 76).

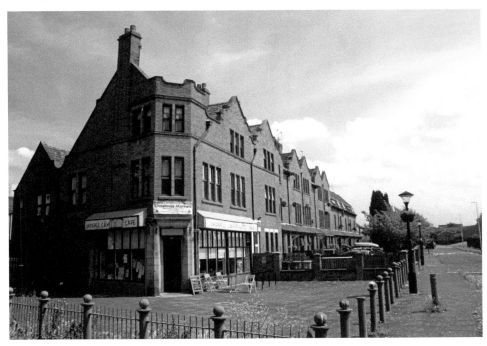

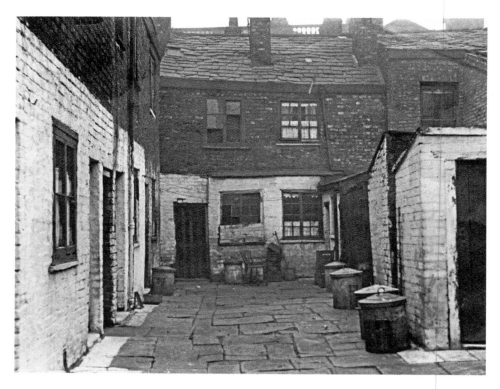

Ordsall Lane

Two contrasting photos of housing close to Ordsall Lane. The upper photo, taken in 1947, shows a classic Salford backyard. The lower photo was taken from Woden Street Foot Bridge (see page 2), with brand new riverside housing along the River Irwell.

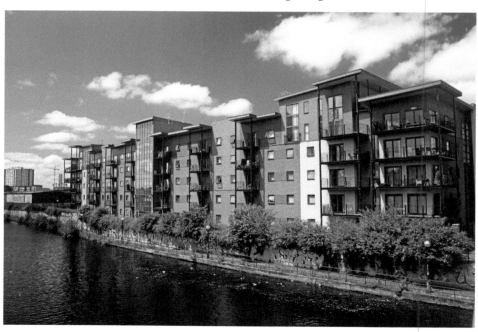

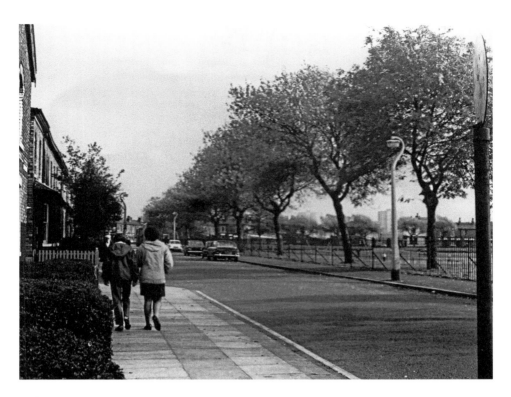

Hulton Street

This street runs along the northern edge of Ordsall Park, formerly linking Trafford Road to Ordsall Lane. It is no longer a through route and is now accessed via the rerouted Phoebe Street and what little remains of West Craven Street.

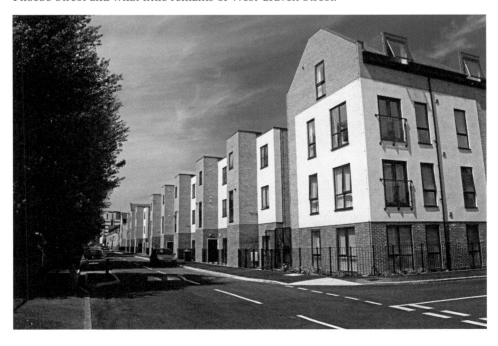

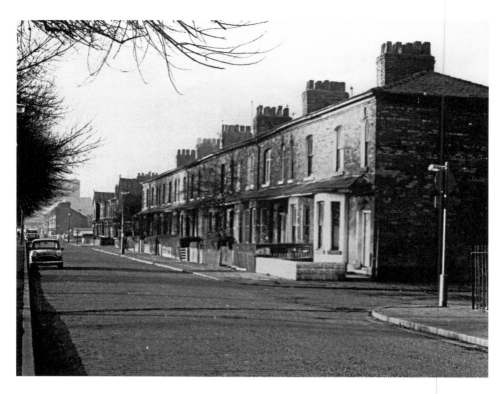

Hulton Street

The housing facing the park has recently been redeveloped. St Clements Church (see pages 42–43) is now at the eastern end of the street.

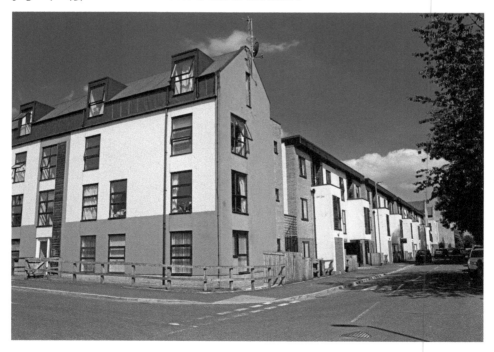

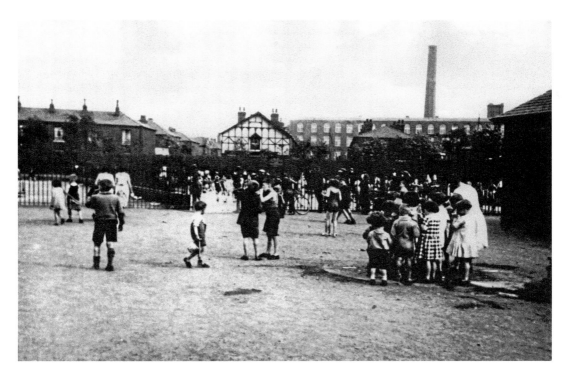

Ordsall Park

The park was created in 1879, and the upper photo shows Haworth's Mill in the background. The park is now largely an open green space.

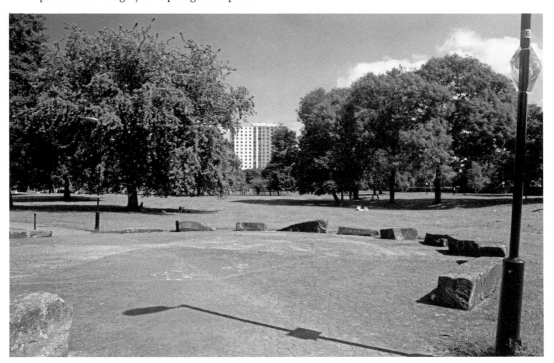

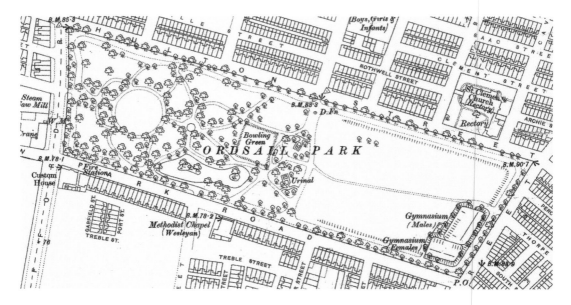

Ordsall Park

The Ordnance Survey map of 1896 shows the park with few facilities. By 1932 the park had two bowling greens, a putting green, a tennis ground, a bandstand, children's playground, drinking fountains, a paddling pool and a lake. The paddling pool and drinking fountains were closed in 1936 after an outbreak of diphtheria and typhoid.

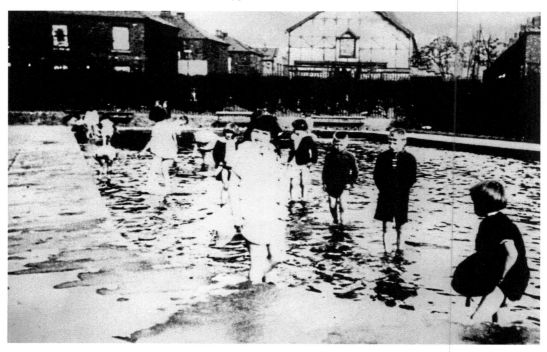

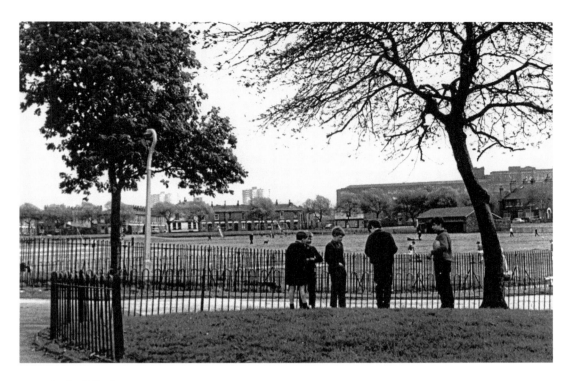

Ordsall Park
The photo of a group of boys in the park was taken in 1967. The park badge is close to the entrance at St Clements Church.

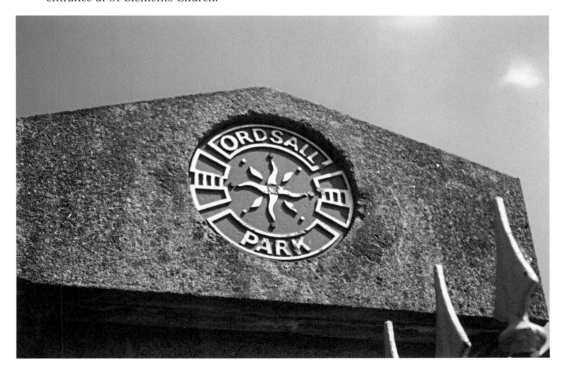

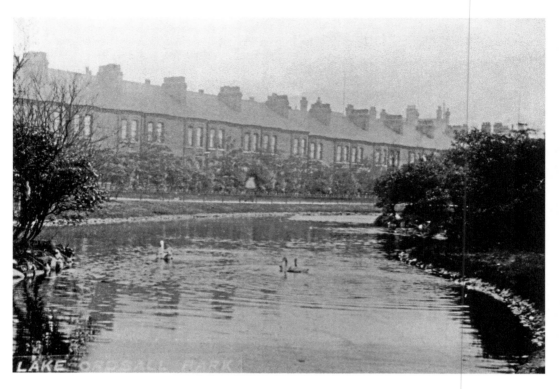

Ordsall Park
The lake was on the southern edge of the park, alongside New Park Road; most of the lakes in Salford's parks were filled in after the Second World War. Below is an uplifting logo on a redevelopment hoarding on Hulton Street.

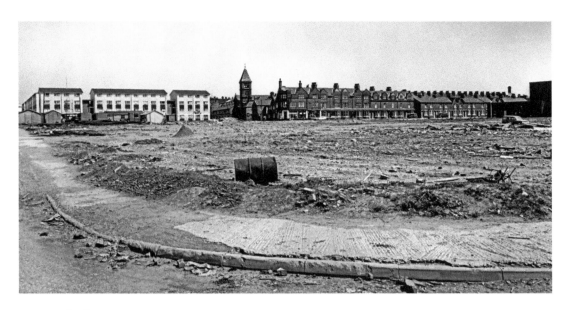

Ordsall

The upper photo, probably taken in the 1960s, shows the sheer scale of the demolition in central Ordsall. The remaining houses are on Tatton Street and part of that row still survives (see page 80). St Ignatius Church can be seen beyond, and Phoebe Street is to the left. The lower photo shows a typical 'Coronation Street' view of Ordsall before demolition. The large building in the background was not identified on the print.

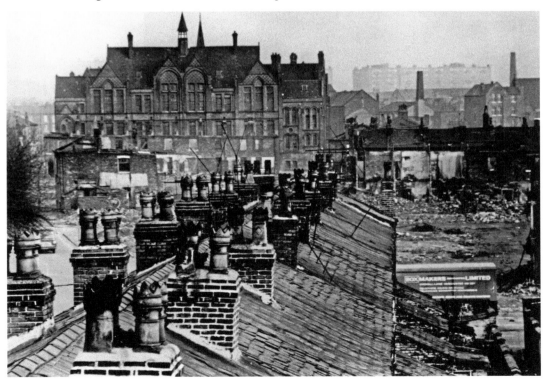

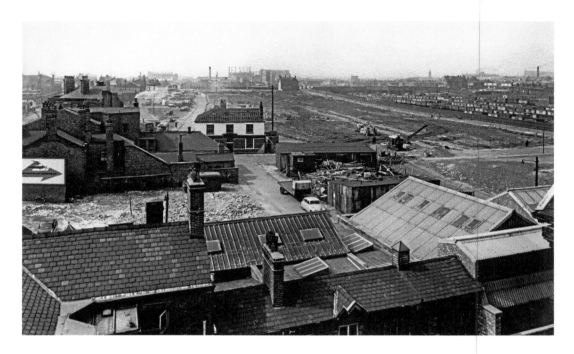

Ordsall

The upper photo, taken in 1958, shows one of the earliest post-war redevelopment areas in Ordsall. It was taken from the roof of Regent Road Brewery (see page 54), looking west. The brewery site is now occupied by the Campanile Hotel. Regent Road is to the left and part of the vast Ordsall Lane railway sidings can be seen to the right. Three pubs are still standing, and the distant gasometer still stands today. The site is now occupied by a retail park, including Sainsbury's supermarket. The lower image shows Regent Road Baths (actually on Derby Street), opened in 1892; nothing now remains.

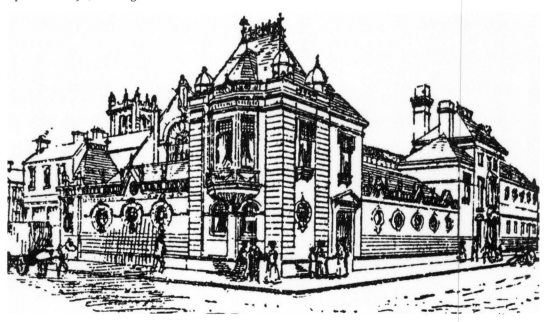

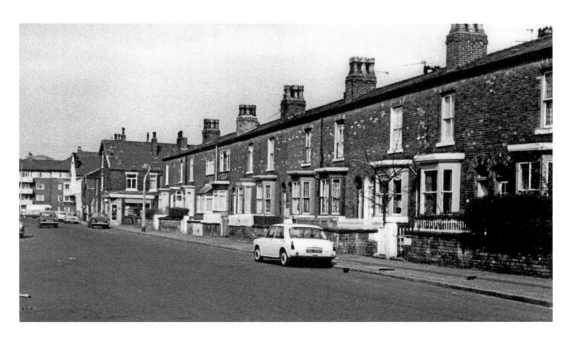

Weaste

Most of the housing and the streets in Weaste south of Eccles New Road have disappeared. The upper photo shows Thurlow Street in 1973. It is now no longer a through road and is largely occupied by industrial premises. The lower photo shows Howard Street, 200 yards to the east, one of the few streets to have been redeveloped for housing in this area.

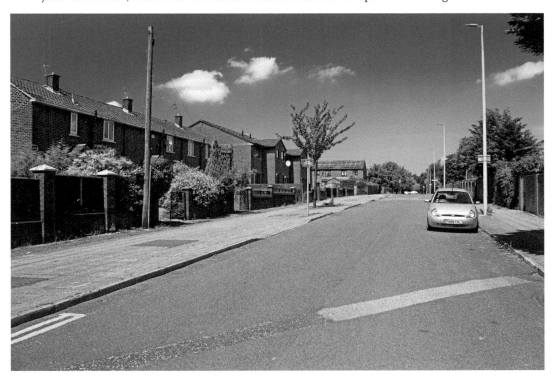

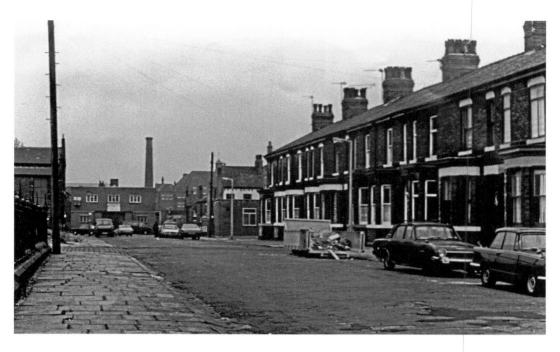

Cemetery Street

This street links Eccles New Road to Weaste Cemetery. The houses on the right-hand (east) side have survived, but the free library, church and school on the opposite side have gone.

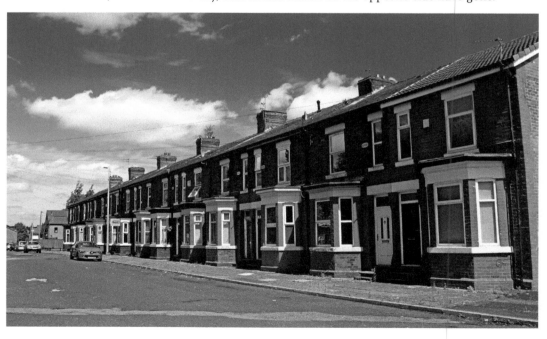

Weaste Cemetery

Weaste has Salford's oldest cemetery, opened in 1857. It covers 39 acres, has seen over 332,000 burials, and is an amazing tranquil green oasis in the city. The cemetery itself is Grade II listed, as are six individual memorials. The 1896 25-inch map shows five drinking fountains and the three mortuary chapels, none of which survive today. Opposite is an old photo of the Roman Catholic chapel, and below is a rather faded interpretative sign in the cemetery showing all three chapels. The ruins of the Cemetery Lodge are still visible. There is a Heritage & Ecology Trail around the cemetery.

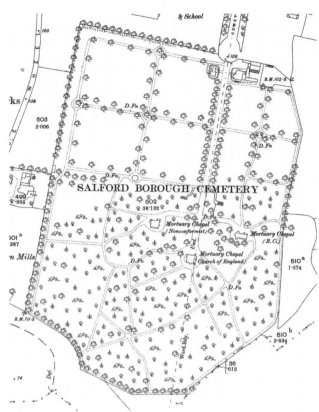

SALFORD BOROUGH CEMETERY

Mortuary Chapel
Nonconformist

Mortuary Chapel
(R.C.)

Mortuary Chapel
(Church of England)

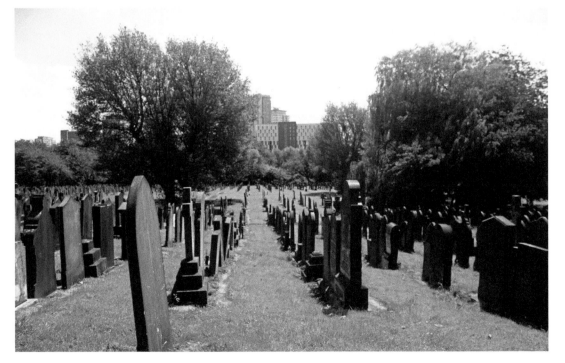

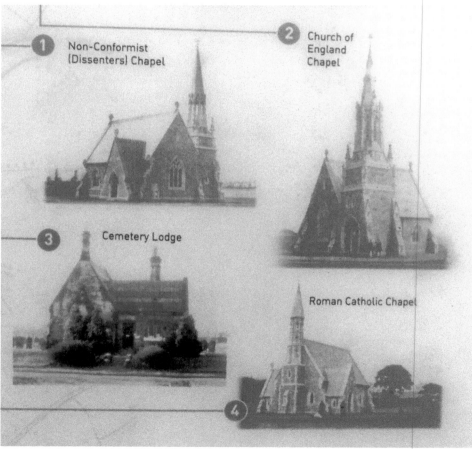

1 Non-Conformist (Dissenters) Chapel

2 Church of England Chapel

3 Cemetery Lodge

Roman Catholic Chapel

4

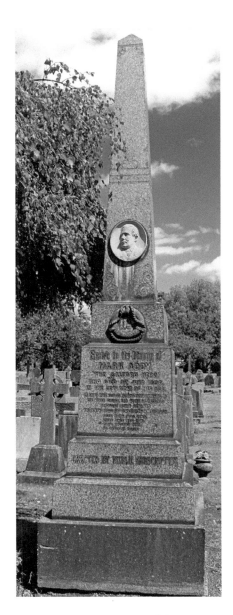
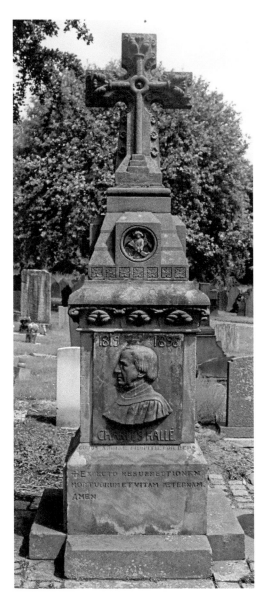

Weaste Cemetery Memorials

Above (left) is the memorial to Mark Addy (1838–1890), a boatman and innkeeper who lived at the Old Boathouse Inn in Everard Street. He was known as 'The Salford Hero' as he had rescued over fifty people from drowning in the River Irwell. He was recognised by the citizens of Salford in 1878 with a loyal address and a purse of 200 guineas, and received the Albert Medal from Queen Victoria a year later. Sadly, after his last rescue, he fell ill having swallowed the heavily polluted waters of the Irwell, and died in June 1890, aged fifty-two. Funds poured in from the people of Salford, and his memorial is one of the tallest in the cemetery. Until recently there was a pub named after him next to Albert Bridge in Salford.

To the right is the memorial to Sir Charles Hallé (1819–1895). He was a German pianist and conductor who came to Manchester in 1853, and founded the fledgling Hallé Orchestra in 1858. He was knighted in 1888.

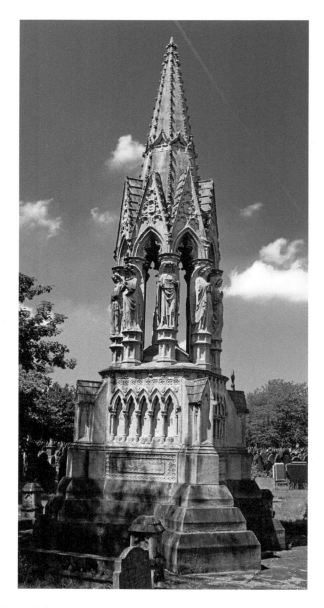

Weaste Cemetery Memorial

This memorial is to Joseph Brotherton (1783–1857). He was a reforming Liberal politician, nonconformist minister and pioneering vegetarian. His father had established a cotton and silk mill in Salford in 1789, but Joseph left the firm in 1819 to campaign for social reforms. After the Reform Act of 1832 he was elected as the first Member of Parliament for Salford, and was re-elected five times. He campaigned for abolition of the death penalty and slavery, and for free non-denominational education. He was involved with the creation of the Manchester Chamber of Commerce and the *Manchester Guardian*, and was largely responsible for the opening of Peel Park and Weaste Cemetery. He was the first person to be buried in Weaste Cemetery, and after his death Salford citizens raised money for an 'enduring memorial'. It is the largest memorial in the cemetery, standing 30 feet high – a fine example of Victorian funerary architecture.

Some Key Dates

1177	First mention of Ordsall
1251	First mention of Manor of Ordsall
1335	Radclyffe family inherits Ordsall Hall
1360	Oldest part of present Ordsall Hall (Star Chamber) built
1510	Great Hall built at Ordsall Hall
1662	Radclyffe family sells Ordsall Hall
1721	River Irwell made navigable to Liverpool
1806	Regent Road/Eccles New Road created in a turnpike Act
1819	Infantry barracks on Regent Road began
1830	Liverpool–Manchester Railway opened
1842	First Manchester and Salford regatta held on River Irwell
1852	Salford Union Workhouse, Eccles New Road, opened
1857	Weaste Cemetery opened
1867	First meeting held at New Barns racecourse
1869	Stowell Memorial Church consecrated
1870	Wesleyan Chapel, Regent Road opened
1871	St Joseph's RC Church opened
1873	Regent Road Brewery opened
1873	Regent Road Library opened
1875	Ordsall Hall used as a working men's club
1878	St Clements Church consecrated
1879	Ordsall Park opened
1885	Ordsall and Trafford Road Boys' Schools opened
1887	Buffalo Bill's Wild West Show opened at the racecourse
1892	Regent Road Baths opened
1894	Manchester Ship Canal opened
1898	Ordsall Hall opened as a clergy training school
1899	St Cyprian's Church consecrated
1900	St Ignatius Church opened

1900–04	Salford Barracks redeveloped
1901	Last meeting at New Barns racecourse
1902	First Salford electric tramways opened
1903	Regent Road Lads Recreation Club opened
1904	Salford Lads Club opened
1905	Dock 9 opened
1907	Salford Central Mission opened
1908	Alistair Cooke born at No. 7 Isaac Street
1915	New Salford Dock Mission opened
1926	Salford workhouse demolished
1932	New Trafford Road Bridge opened
1941	First permanent British Restaurant opened at Ordsall Park
1947	Last Salford tram ran
1952	Palace Theatre, Cross Lane, destroyed by fire
1953	Walker & Homfrays Brewery, Eccles New Road, closed
1958	Ordsall demolition and redevelopment begins
1960s	St Cyprian's Church demolished
1972	Ordsall Hall Museum opened
1982	Docks closed
1983	Docks bought by Salford Council
1985	Salford Quays Development Plan
1986–90	Docks 7–9 dammed and modified; low-rise Merchants Quay built
1985–95	Low-rise Grain Wharf housing built
1999	Metrolink reaches Salford Quays
2000	The Lowry opened
2001–07	High-rise developments built in Salford Quays (Imperial Point, Sovereign Point, NV Buildings, City Lofts)
2009–11	Major restoration of Ordsall Hall
2007–10	MediaCityUK built
2010–11	BBC and Salford University move departments to MediaCityUK
2010	Metrolink extended to MediaCityUK

Further Reading

Bergin, T., Pearce, D. N. & Shaw, S., *Salford: A City and its Past,* 1989
Dickens, S., *Manchester Ship Canal Through Time,* 2017
Gray, E., *Salford,* 1995/2001
Hayes, C., *The Changing Face of Salford,* n.d.
Nevell, M. & George, D., *Recapturing the Past of Salford Quays,* 2017
Ordsall Hall (Guidebook), n.d.

About the Author

After taking (very) early retirement from being a Senior Lecturer in Geography at Salford University, Paul now concentrates on researching, writing and lecturing in various fields of historical geography. His main academic interests are old maps, roads, canals and the Lake District. Other interests include limestone landscapes and caves, and towns and roads in medieval England.

He has written several books, including:

Maps for Historians (Phillimore, 1998)
Roads and Tracks of the Lake District (Cicerone, 1998, 2011)
Roads and Tracks for Historians (Phillimore, 2001)
Medieval Town Plans (Shire, 1990–2011)
Medieval Roads & Tracks (Shire, 1982–2016)

Plus two books in the Amberley *Through Time* series:

Manchester Bolton & Bury Canal Through Time (Amberley, 2013)
Salford Through Time (Amberley, 2014)

He has also written commentaries for reproductions of numerous maps in the Godfrey Edition of early Ordnance Survey maps.

He is Editor of *North West Geography*, the e-journal of the Manchester Geographical Society, of which he is Honorary Secretary (www.mangeogsoc.org.uk).

He is Chairman and Editor of the Manchester Bolton & Bury Canal Society (www.mbbcs.org.uk).

bienvenue à
wilkommen in
siyakwamkela e
welcome to
SALFORD QUAYS
in the great city of SALFORD